FABERGÉ FLOWERS

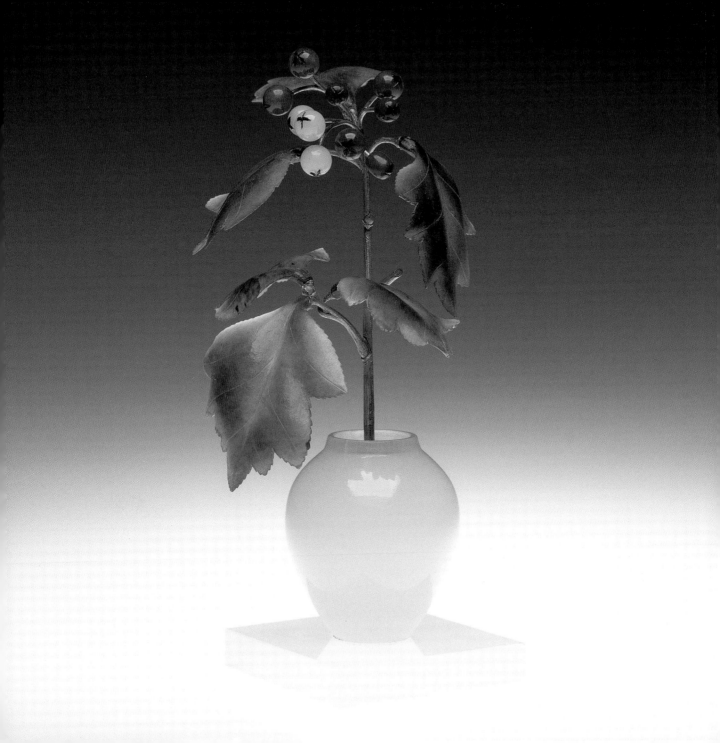

FABERGÉ FLOWERS

Marilyn Pfeifer Swezey

WITH

Caroline de Guitaut
Ulla Tillander-Godenhielm
Tatiana Fabergé
Valentin V. Skurlov
Alexander von Solodkoff
and Mark A. Schaffer

EDITED BY

Joyce Lasky Reed and Marilyn Pfeifer Swezey

English Hawthorn. Fabergé,
Workshop of Henrik
Wigström, 1903–1917. Gold,
agate, jasper, nephrite, jade.
Height 5½ in. Marks: *H.W.*
for Henrik Wigström; *72*,
Russian gold mark; *Faberge*
in Cyrillic letters. The New
Orleans Museum of Art:
Matilda Geddings Gray
Foundation Loan

HARRY N. ABRAMS, INC., PUBLISHERS

Editor: Elaine M. Stainton
Designer: Miko McGinty
Production Manager: Jane G. Searle

Library of Congress Cataloging-in-Publication Data

Swezey, Marilyn Pfeifer.
 Fabergé flowers / Marilyn Pfeifer Swezey et al. ; with
an introduction by Alexander von Solodkoff and essays
by Marilyn Pfeifer Swezey ... [et al]. Edited by Joyce
Lasky Reed and Marilyn Pfeifer Swezey.
 p. cm.
 Includes bibliographical references and index.
 ISBN 0–8109–4953–9 (hardcover)
 1. Faberge, Peter Carl, 1846–1920—Criticism and
interpretation. 2. Art objects—Russia (Federation) 3.
Flowers in art. 4. Decoration and ornament—Art
nouveau. I. Swezey, Marilyn Pfeifer. II. Title.

 NK7198.F18R44 2004
 739.2'092—dc22
 2004000872

Printed and bound in China

10 9 8 7 6 5 4 3 2 1

Harry N. Abrams, Inc.
100 Fifth Avenue
New York, N.Y. 10011
www.abramsbooks.com

Abrams is subsidiary of

LA MARTINIÈRE
GROUPE

Miniature Basket of Lilies of
the Valley and Miniature
Watering Can: Fabergé, c.
1900. Nephrite, enamel, dia-
monds. Height 4⅛ in. Marks:
scratched inventory mark,
4709. Formerly, the Forbes
Collection, New York

This miniature watering can
is carved from a single
piece of nephrite. The han-
dle and nozzle of scarlet
guilloche enamel are set
with rose diamond borders.
This charming piece was
formerly in the collection
of Mme. Elizabeth Baletta,
actress of the Imperial
Michael Theater in St.
Petersburg, to tend her col-
lection of Fabergé enamel
and hardstone flowers.

The miniature basket of lilies
of the valley is shown in
greater detail and discussed
on pp. 22–23.

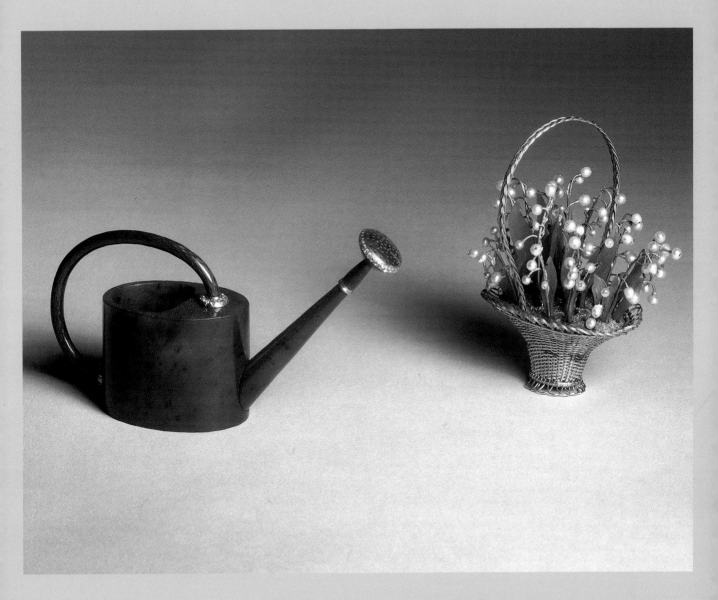

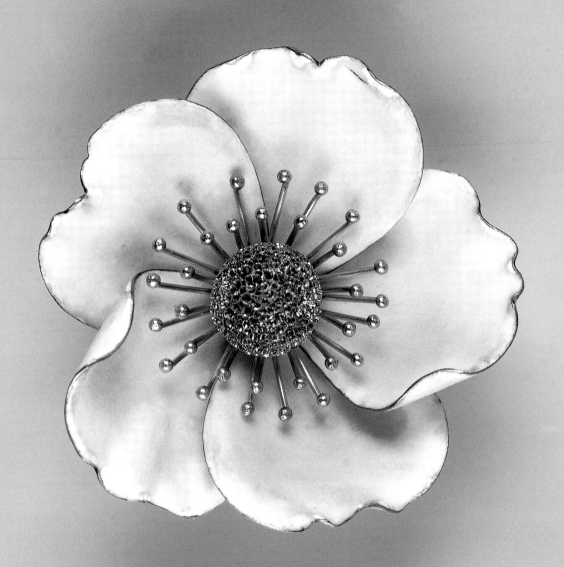

Contents

11 Preface
Joyce Lasky Reed

17 Introduction
Alexander von Solodkoff

27 "A Thing of Beauty is a Joy Forever": The Fabergé Flowers
Marilyn Pfeifer Swezey

63 An Astonishing Discovery
Ulla Tillander-Godenhielm

81 "His Greatest Patroness": Queen Alexandra and Fabergé's Flowers
Caroline de Guitaut

100 Fabergé's London Branch and the London Ledgers
Tatiana Fabergé

103 In Search of Fabergé Flowers in Russia
Valentin V. Skurlov

117 Fabergé's Flowers: Science in the Service of Art
Mark A. Schaffer

124 Index

Wild Rose Brooch. Fabergé,
c. 1900. Gold, enamel.
Diameter 1½ in. Unmarked.
Virginia Museum of Fine Arts

Wild Rose. Fabergé,
c. 1900. Gold, enamel, silver,
diamond, nephrite, rock
crystal. Height 4 in.
Unmarked. The Cleveland
Museum of Art

Preface ❧ Joyce Lasky Reed

Once upon a time, there were two Danish princesses. The younger, Dagmar, grew up to marry Alexander III and became Tsarina of Russia. The elder, Alexandra, married Edward VII, and became Queen of England. The sisters' passion for flowers and for the work of Carl Fabergé would be the decorative hallmark of their collections. Each presided in her respective sitting room, surrounded by an artful clutter of objets d'art.

This European fairytale ended in 1918 after a catastrophic world war and the onset of a horrific Soviet dictatorship. While the British royal collection remained intact, the Russian imperial pieces were looted, confiscated, and many were later sold to western buyers for hard currency.

A little over a decade ago, with freedom of movement in Russia established, the search for the whereabouts of the scattered St. Petersburg pieces of Fabergé began in earnest. A lost ledger emerged, a memoir was unearthed, a bequest came to light, a diary discovered—each iota of information became a clue—evidence of who bought what, for whom, and when. Today, Fabergé scholars, armed with sharp eyes, persistence, and a passion for the unknown, are bringing the history of the Fabergé workshops and of the royal life of St. Petersburg into sharper focus.

What master sleuths the Fabergé mystery has enticed! They include historians, stylists, artists, and geologists. In the creation of this volume, we have gathered some of the most eminent: Marilyn Swezey, Ulla Tillander-Godenhielm, Alexander von

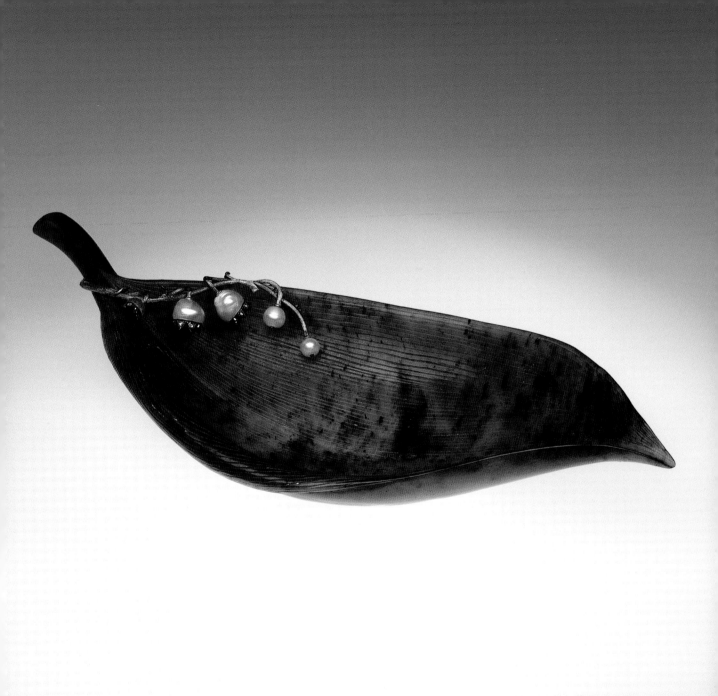

Solodkoff, Valentin Skurlov, Tatiana Fabergé, Mark Schaffer, and Caroline de Guitaut. Each writer in turn has examined the fragmentary evidence and reflected on the pieces and the players, thus catching a different prism of light. Forgotten history is now being pieced together.

We pursued the magic of the search and the culture of the flowers, following an inspired suggestion: The idea for the book began with Princess Nina Lobanov-Rostovsky. For instantly recognizing that this volume on Fabergé and flowers would be the first ever published on the subject, we are grateful as well to Eric Himmel, editor-in-chief of Harry N. Abrams.

<div style="text-align: right">

Joyce Lasky Reed, President
Fabergé Arts Foundation

</div>

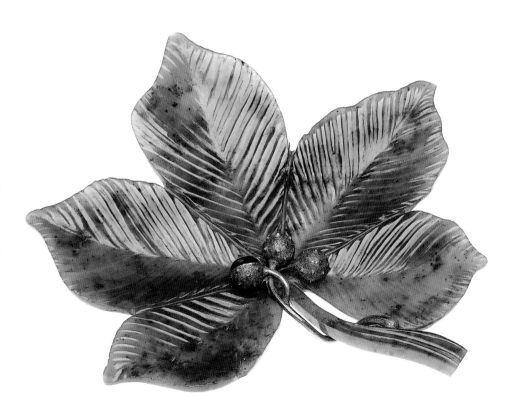

Mistletoe Spray. Fabergé,
c. 1900. Gold, moonstones,
nephrite, rock crystal.
Height 5½ in. Unmarked.
The Brooklyn Museum of Art

Seven moonstone berries
in two clusters with pale
nephrite leaves are set on a
gold stem placed in a rock
crystal vase with carved
water. Mistletoe, a rare and
exotic plant in Russia but
popularly associated with
Christmas in the West, is a
surprising subject for a
Fabergé study.

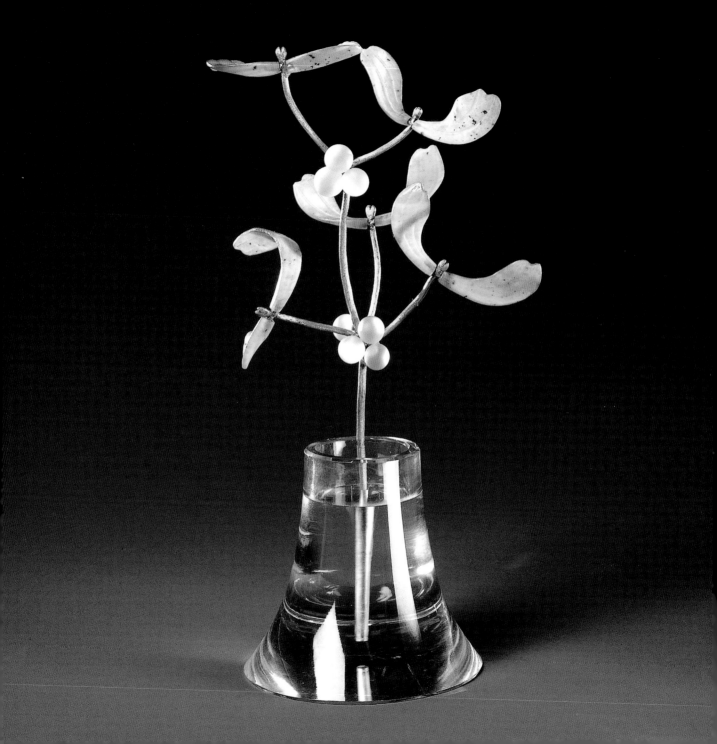

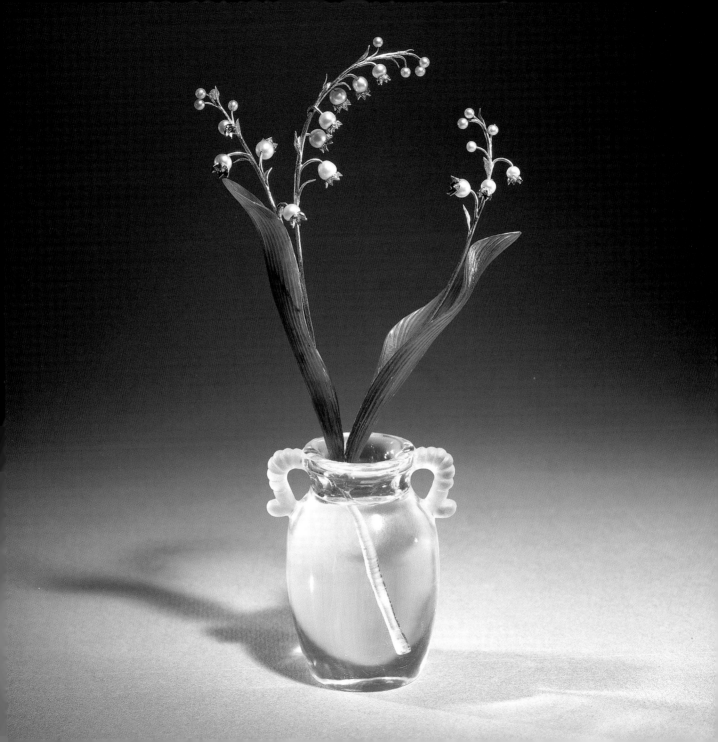

Introduction ∽ Alexander von Solodkoff

Flowers, a true Russian luxury. These words by Theophile Gautier (1811–72) surely referred, not to the floral creations of Carl Fabergé, but to natural flowers—whether grown wild or in greenhouses—for which the Russians always had a special inclination. At first thought, flowers seem to be the opposite of everything we normally associate with the Russian climate. One thinks of snowstorms and horse-drawn troika sleighs or even Russian folk tales about *Morozko* and *Father Frost*. However, once the severe winter is over, the great thaw sets in and rapidly the first signs of growing plants with budding flowers are to be seen. Not without reason, Easter, the feast of the Resurrection of Christ, has special significance for Russians, for it also coincides with the resurgence of nature.

Fabergé seems to have understood the country's psychology. Already well-known for his Easter creations in the shape of elaborately jewelled eggs, he turned to the beauty of nature, especially flowers. The Russian love of nature and flowers is well explained in this volume in the essay by Marilyn Swezey, which is supported by archival material recently discovered by the St. Petersburg researcher Valentin V. Skurlov. Russians always like the study of nature, and even members of the Imperial family painted flowers in watercolors. A pretty example of this by Empress Alexandra Feodorovna (1872–1918), signed with her initials and dated 1912, was found with a photograph of the tsarevich pasted onto it, a memento for her sister, Princess Irène

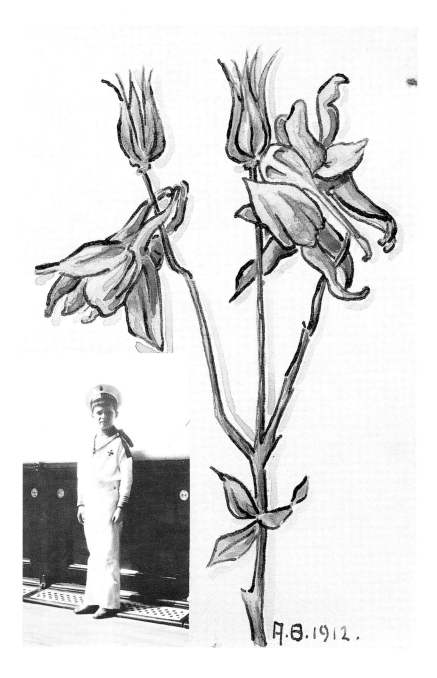

A·B·1912.

Aquilegia painted by
Empress Alexandra
Feodorovna in 1912
with a photograph of
Tsarevich Alexei pasted
onto it. 5¾ in. x 3¾ in.
Photo: Solodkoff/
Hemmelmark Archives ©

(1866–1953). The watercolor shows a sprig of aquilegia with blossoms painted in the mauve color the Empress liked so much. In its simplicity it could have inspired Carl Fabergé for one of his creations.

Growing up during a period of eclecticism, Fabergé took his ideas from art forms from around the world. Most influential for him were Chinese flowers composed of carved hardstones, which, according to Franz P. Birbaum (1872–1947), his chief designer, gave him the original idea to create his own flower arrangements. Fabergé was able to amalgamate these Chinese influences into a creation of his own. Thus he condensed the Russian love of flowers into an art form that is striking in its simpicity, and seems the opposite of the baroque opulence of the *Belle Epoque*. Although we often think that they might have been inspired by the minimalistic art of Japan, Fabergé flowers do not impress the Japanese much when they see them today.

It helped, of course, that Fabergé had the best goldsmiths and other craftsmen of the time at hand to produce objets d'art that transformed nature into jewels. His flower sprigs made of gold, hardstones, or enamel appear to be snapshots of transient life. The eye of the onlooker is typically bewildered by seeing water in the clear vase carved *en trompe l'oeil* from rock crystal. The essay by Ulla Tillander-Godenhielm in this book explains in detail how the flowers were manufactured in Fabergé's workshops. It was a great challenge for the craftsman to carve an extremely thin leaf from nephrite, sometimes with ridged edges, and often with natural veining and even twisted foliage curls. What a fabulous idea to re-create branches of lilies of the valley with natural pearls—which had such a high value at Fabergé's time—each minutely set with a crown of tiny blinking rose-cut diamonds. Perfume made from these flowers was extremely popular with the ladies of the *Belle Epoque*. Fabergé's creations also found great success.

Around 1910, Fabergé flowers became a true luxury, not only of St. Petersburg, but also of Edwardian society. Naturally, the Dowager Empress Marie Feodorovna (1847–1928), as well as Tsar Nicholas II (1868–1918), purchased flowers from Fabergé. It is fascinating to trace other owners of flower collections, such as Countess Alexander Mordvinoff (1886–1943), a wealthy member of St. Petersburg society related to the Dukes of Oldenburg. She is said to have had her huge, white marble-clad bathroom

decorated with cut-glass shelves displaying a row of never-fading flower creations by Fabergé standing in the scented hot steam. The celebrated prima ballerina Mathilda Kschessinska (1872–1971) had a "huge collection of wonderful artificial flowers made of precious stones." Grand Duchess Marie Pavlovna (1854–1920), the wife of the tsar's uncle, the Grand Duke Vladimir, was another enthusiastic collector of flowers, which she either acquired herself or received as presents, mainly at Easter. In 1917, an assembly of thirty-four flower still lifes was found in the drawing rooms of her mansion on the Palace Quai in St. Petersburg. However, all these collections in Russia were dispersed in the aftermath of the Revolution.

Not surprisingly, Queen Alexandra (1844–1925) was initally shown the works of Fabergé by her sister, Empress Marie Feodorovna. She not only collected carved hardstone animals but also Fabergé flowers, which are still in the Royal Collections of the Queen of England and are described in this book in detail by Caroline de Guitaut. It is interesting to follow in her essay the forming of an outstanding collection, the only original one still in existence. Some flower pieces in the Royal Collection were added in later years. One of them is a rock crystal vase combining two enameled diamond-set cornflowers and a curved spray of oats made of chased gold. Each single husk is suspended from a tiny gold ring that trembles at the slightest breath of air. This unusual Fabergé creation was purchased by Queen Elizabeth (1900–2002), the mother of the present queen, with a contribution from her mother-in-law, Queen Mary (1867–1953). When Queen Elizabeth showed this author her Fabergé collection at Clarence House in 1981, she remembered this piece standing on her desk in the shelter room at Buckingham Palace during World War II. This gallant lady, who with her husband, King George VI, courageously stayed on in London during the entire war, recalled how the oat stalk shook when flying-bombs fell: "However awful the moment, it was so enchanting to see this charming and so beautifully unwarlike plant starting to tremble when most horrible things were approaching."

Cornflowers and Oat Sprays. Fabergé, c. 1900. Gold, enamel, diamonds, rock crystal. Height 7½ in. The State Hermitage Museum, St. Petersburg

In this fanciful combination, two blue enameled cornflowers with a cluster of rose diamond pistils in the center stand next to a stem of gold oats with loosely swinging seeds in a cylindrical rock crystal vase carved to simulate water. The piece was originally in the collection of Prince Youssoupof.

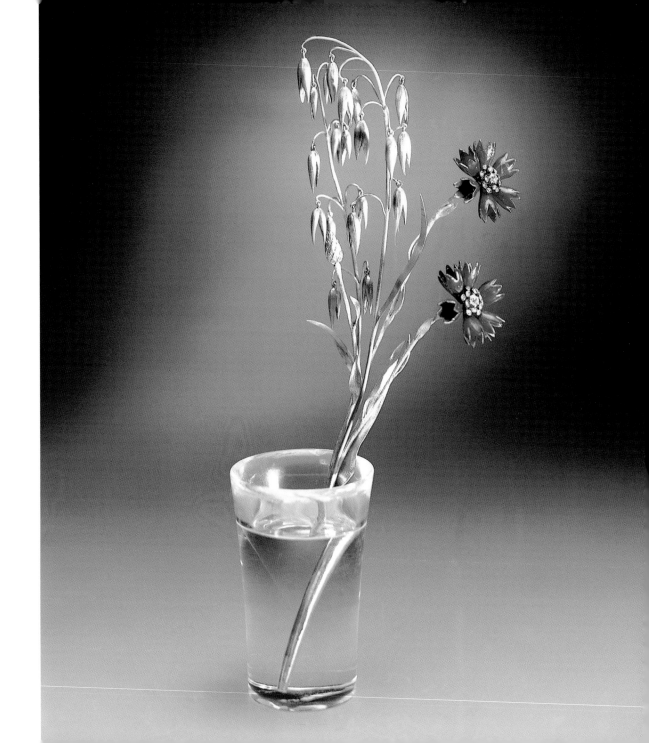

Miniature Basket of Lilies of
the Valley. Fabergé,
Workshop of Mikhail
Perkhin, before 1896. Gold,
pearls, nephrite. Height 3⅛
in. Marks: initials of Mikhail
Perkhin in Cyrillic; St.
Petersburg mark before
1896. Formerly, the Forbes
Collection, New York

Twenty-four tiny sprays of
lilies of the valley grow in a
plaited gold "wicker" bas-
ket. Each gold stem is set
with pearl flowers and a
finely engraved nephrite
leaf. This study is similar in
concept to the Imperial
Basket of Lilies of the
Valley, which stood on the
writing table of Empress
Alexandra (see p. 49). It
was formerly in the collec-
tion of H.R.H. Princess
Marina of Kent, grand-
daughter of Grand Duke
Vladimir Alexandrovich and
Grand Duchess Marie
Pavlovna, who had the
largest known collection of
Fabergé flowers.

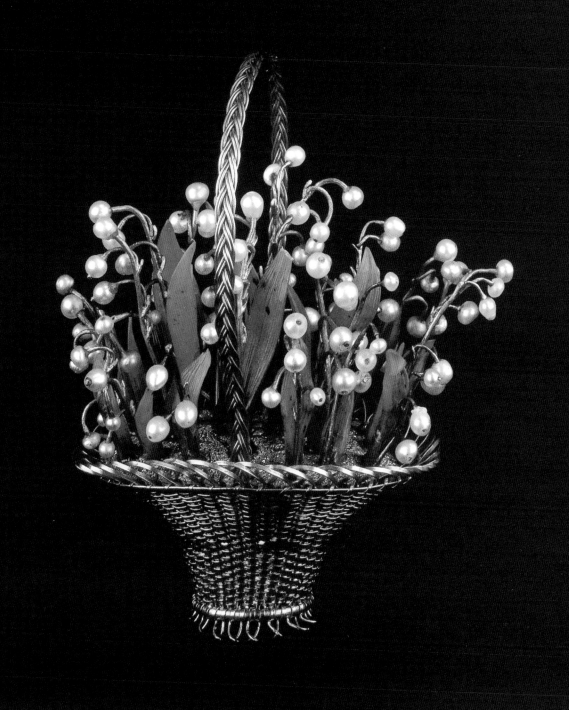

Wild Pansy Sprig. Fabergé, Workshop of Henrik Wigström, 1899–1908. Gold, enamel, rose diamonds, nephrite, rock crystal. Height 4 7/8 in. Marks: *H.W.* for Henrik Wigström; *72,* Russian gold mark; *Faberge* in Cyrillic letters; assay mark of St. Petersburg; scratched inventory no. *13721.* Formerly, the Forbes Collection, New York

A gold stem of three pansies realistically enameled in shades of purple and white, each with a diamond center and green enamel calyx, with five carved nephrite leaves, stands in a rock crystal vase of carved water.

Formerly in the collection of H.R.H. Princess Marina, Duchess of Kent, granddaughter of Grand Duke Vladimir Alexandrovich (brother of Alexander III) and Grand Duchess Marie Pavlovna. The scratched inventory number indicates that this piece was a royal commission.

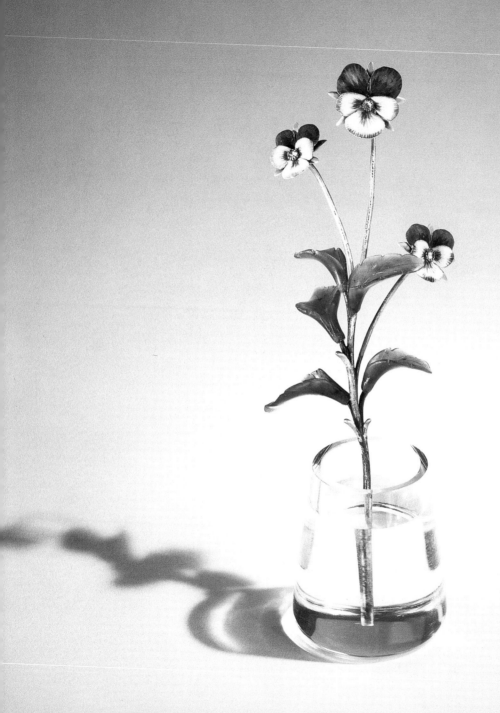

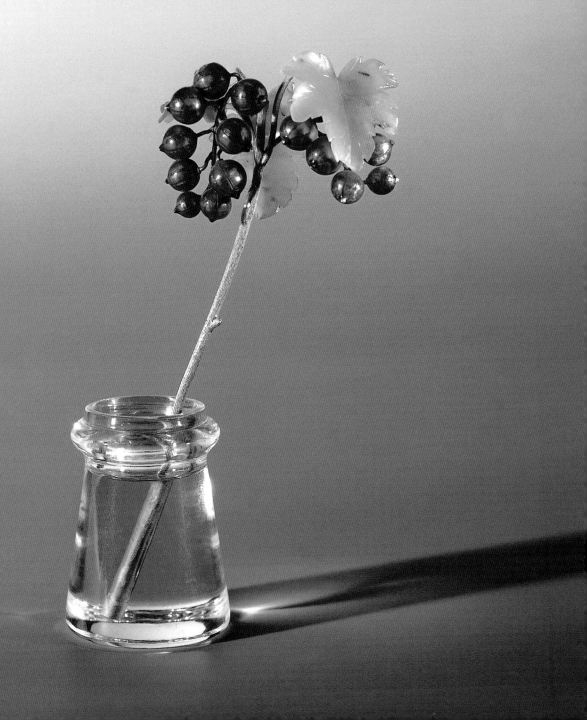

"A Thing of Beauty is a Joy Forever": The Fabergé Flowers

Marilyn Pfeifer Swezey

Carl Fabergé may never have read the poetry of England's John Keats, but this romantic sentiment seems appropriate to describe the little flowers made of hardstone, enamel and gold that came from the workshops of the renowned artist-jeweler during the last decades of Imperial Russia.

Very simple in concept, but ingenious in their craftsmanship, these small sprigs of flowers and berries in vases are the rarest of the decorative art objects produced by the Fabergé workshops. Thousands of objects were made, many of them decorated with floral themes (p. 28), but fewer than a hundred of the flower studies, as they were called, are known to exist today. How many of the flowers were produced altogether is unknown. There is no doubt, however, that they were fewer in number than any other of the master's "objects of fantasy."

Individual stems of narcissus, wild rose, bleeding heart and orange blossom, or sprays of lilies of the valley, buttercups, and chrysanthemums, as well as Japanese bonsai and dandelion seed puffs—favorite flowers of the Victorian era—are typically set in a plain vase, usually of rock crystal, carved to look as if it contained water. The blossoms or berries all seem to have just come from nature, freshly picked from the forest or a field—rather than from a well-trimmed garden—and placed in water by an unknown admirer to be preserved. They might be a flowering sprig of Japonica (Flowering Quince) in the spring (p. 80, second from left), a little stem of Red

Compact. Fabergé, Moscow 1896–1908. Gold with chased and carved flowers set with sapphire centers surrounded by rose diamonds. Courtesy of A La Vieille Russie

Currants in the summer (p. 26), or chrysanthemums in the fall (p. 80, third from left). It is the astonishing achievement of the Fabergé craftsman to have reproduced these little sprigs to look as if they were alive. The Fabergé workmasters used ingenious means and perfect craftsmanship to do this, even carving water in trompe l'oeil fashion, out of transparent rock crystal. Leaves of varied shades of green nephrite were realistically veined with carving on both sides; flowers, berries, and sometimes vases were shaped from polished mineral stones, such as rhodonite, nephrite, quartz, and bowenite, all stones so plentiful in the Urals and Siberia. Some of the flowers are enameled in exquisite natural colors over carefully shaped gold or silver, given a subtle accent of tiny rose-cut diamonds and set on gold stems. Alloys such as copper or silver were added to produce different shades of gold to be carefully chased, engraved, and modeled to define details such as the bark, pinecones, and pine needles seen on the bonsai pine tree in a bowenite vase from the workshop of the Fabergé chief workmaster, Michael Perchin (pp. 30–31).

But an artistry even greater than that of their technical perfection is seen in the natural flowing appearance of these flower creations. They are dynamic, as if suspended in a moment of time. One perceives them within an invisible natural environment. The sprig of Wild Cherries (p. 90) evokes the image of a tree in mid-summer. The Narcissus (p. 32) seems to have been just picked from a spring garden, invisibly seen. The full-blown dandelion seed puff (pp. 33, 119) appears just about to be blown away.

The Russian poet Boris Pasternak wrote that art "is not simply a description of life, but a setting forth of the uniqueness of being."[1] The Fabergé designers and craftsmen brought the naturalism of these little blossoms into the realm of art, enabling the viewer to study the species and find joy in the beauty of their being. How else could we look at the dandelion, which is not even a flower, but a weed, and find it more beautiful than a real one, which, from a practical point of view, is just a nuisance in the garden?

There was a great interest in the world of nature and curvilinear motion in the artistic compositions of the Art Nouveau style, which became popular in Europe at the end of the nineteenth century. The theme of flowers, stems, and leaves in a flowing design was characteristic of Art Nouveau, often in a mixture of real and imaginary

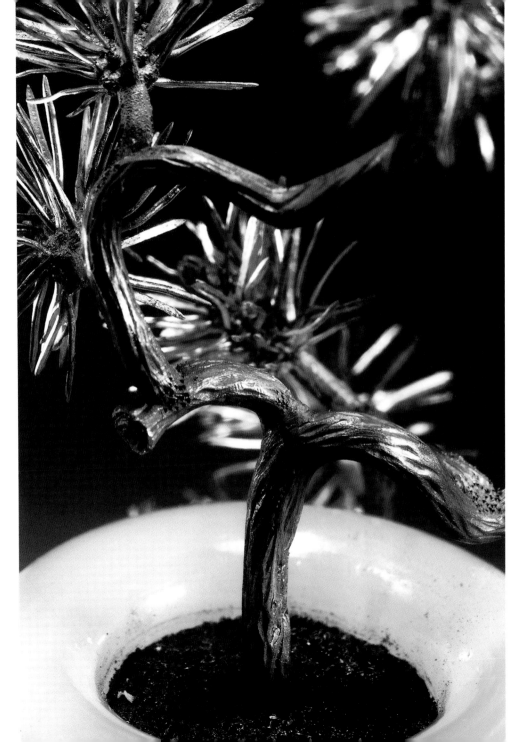

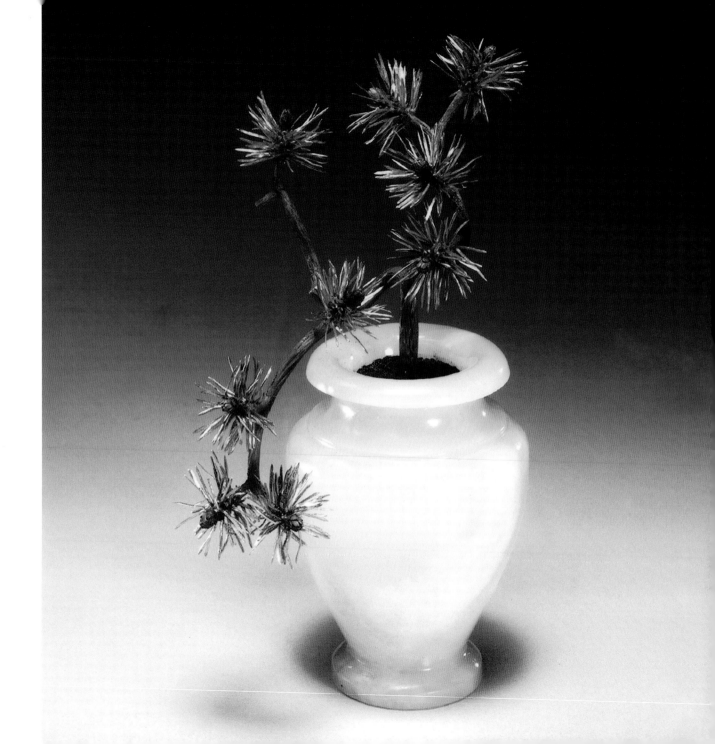

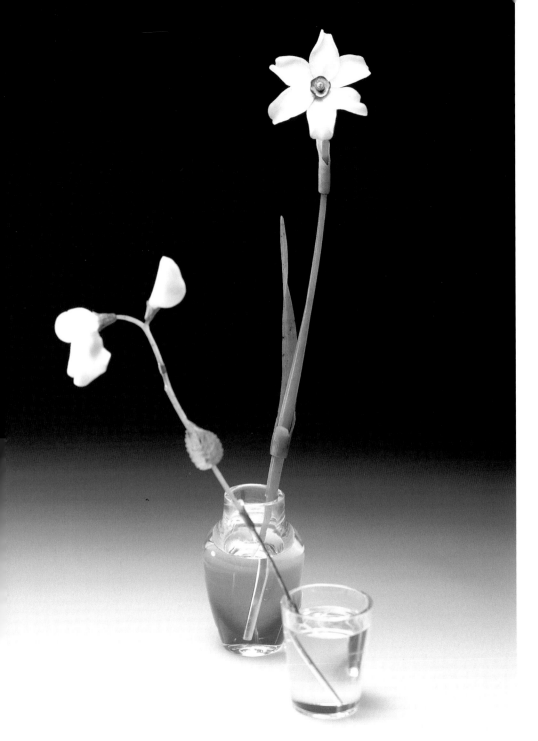

Narcissus and Sweet Peas. Fabergé, c. 1908. Narcissus: gold, cachalong, enamel, nephrite, diamonds, rock crystal; sweet peas: gold, cachalong, nephrite, rock crystal. Heights 10⅝ in.; 5⅛ in. Both unmarked. The State Hermitage Museum, St. Petersburg

These exquisite pieces, originally in the collection of Marie Pavlovna, the Grand Duchess Vladimir, were confiscated in 1919 from A.K. Rudanovsky, a pre-revolutionary antiquarian, and later transferred to the Hermitage.

flowers. The Fabergé flower studies are a unique expression of this Art Nouveau style. While they are realistic in design and concept, they are imaginary in their material form. Fabergé senior master craftsman Franz Birbaum, writing about the technical creation of the dandelions, which were particularly successful, speaks about this artistic distance from nature.

Natural down being attached to gold hair-like lengths of wire with tiny brilliants: the sparkling spots of diamonds among the white fluff produced a wonderful effect and saved these artificial flowers from

Dandelion. Fabergé, c. 1900. Gold, silver, rose diamonds, nephrite, natural dandelion fluff, rock crystal. Height 8½ in. With its original fitted case. Marks: firm inventory no. *19784.* State Museums of the Moscow Kremlin

This dandelion was discovered in an old Moscow residence still in its original case and acquired by the Purchasing Commission of the Kremlin Museums in 1994. The dandelion's seed ball is composed of diamond-tipped gold thread among natural and fluff set on a curving gold stem with two nephrite leaves in a rock crystal vase with carved water.

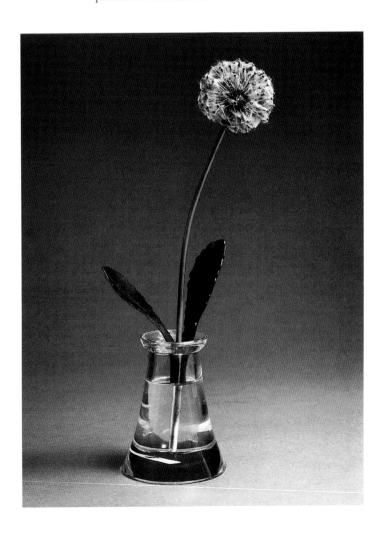

unduly close imitation of nature. The artistic image was preserved so that these objects did not imitate nature too closely.[2]

The Japanese style of composition was also characteristic of Art Nouveau, which can be seen in several Fabergé flower studies (p. 31).

Essentially, the flowers are all made in the style of elegant simplicity created by Carl Fabergé for a clientele that he described as "long tired of many diamonds and pearls,"[3] referring to his Imperial patrons and the Court circles of St. Petersburg. Indeed, the glittering court style created by the two empresses of the eighteenth century, Elizabeth and Catherine the Great, remained almost unchanged up to 1917. Silver and gold embroidered gowns, required by court protocol, sparkled with jewels. In the eighteenth century, jeweled bouquets were worn on gowns instead of flowers, and visitors to the court were dazzled by those jewels.

Writing about a state dinner at Peterhof in 1914 in honor of Raymond Poincaré, the President of France, French Ambassador Maurice Paleologue described "the brilliance of the uniforms, superb toilettes, elaborate liveries, magnificent furnishings and fit-

Japanese Floral Composition. Fabergé, St. Petersburg. An arrangement of two dwarf pines of red and green gold and a white enamel flower with a rose diamond center on a gold stem with two nephrite leaves is placed in a carved nephrite vase with an inner copper container filled with rock crystal "water." The vase is set on an eosite table with simulated wood grain and four gold legs. This is one of the finest Fabergé examples of a Japanese flower arrangement. An original Fabergé photograph of this piece is in the archive of the Fersman Mineralogical Institute in Moscow. Height 6¼ in. Courtesy of A La Vieille Russie

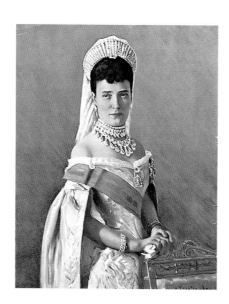

Empress Marie Feodorovna (1847–1928). The former Danish Princess Dagmar, sister of Queen Alexandra of England and wife of Russian Emperor Alexander III, seen here in formal Court dress. Private Collection

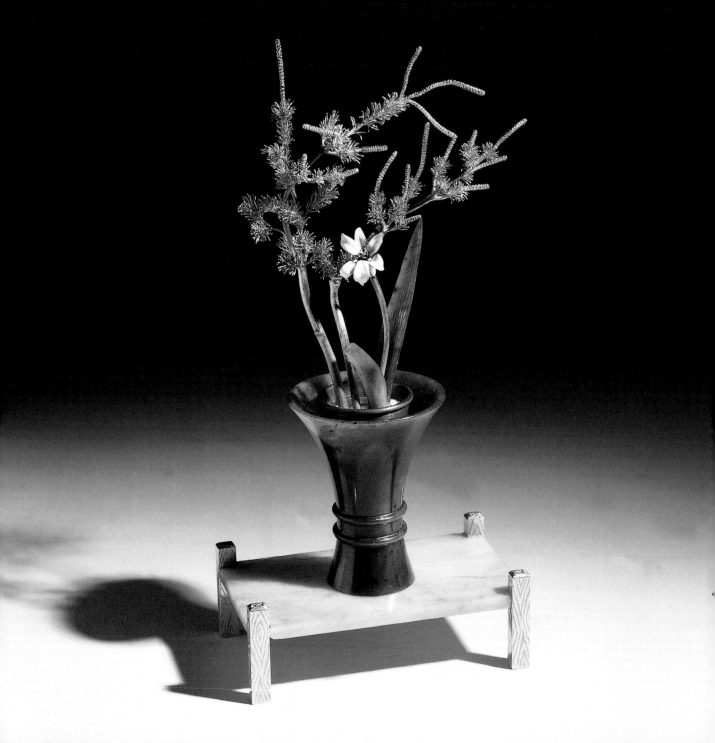

tings, in short the whole panoply of pomp and power" as a "spectacle no court in the world can rival. I shall long remember the dazzling display of jewels on the women's shoulders. It was simply a fantastic shower of diamonds, pearls, rubies, sapphires, emeralds, topaz, beryls—a blaze of fire and flame."[4]

It is not surprising that the small functional objects—table clocks, picture frames, desk accessories, cigarette cases, and decorative objects such as the flowers became popular in these court circles. Jewels were used sparingly and always as part of the artistic design. Small diamonds specially faceted to diminish the brilliance of the stone—rose-cut, and known as "roses"—were frequently used. Rose-cut diamonds can be seen in the center of many of the flowers (opposite). Not all of the flowers were set with gems, however. Some enameled flowers, such as the Buttercup (p. 38), and hard-stone flowers such as the Bleeding Heart (p. 97) are not adorned with gems at all. Fabergé flowers were part of the movement away from the gilded style of the eighteenth and nineteenth centuries in favor of a simplicity that was to become characteristic of the modern era.

Beginning around 1890, the Fabergé workshops began to make enameled flowers with nephrite leaves. The firm soon began to produce hardstone flowers as well, inspired by Chinese gemstone carvings. Birbaum explains how the idea of creating these flowers came about when they were called upon

to repair a bunch of chrysanthemums from the palace of the Chinese Emperor after it had been occupied by the European landing force. Narcissi, jasmine, branches of white lilac and hyacinths were made of white quartz; sweet peas and other gaily colored flowers were made of rhodonite, quartz, cornelian and agate; leaves were usually made of nephrite, occasionally of green jasper and quartz. The flowers were sometimes put into rock crystal vases, hollowed only in the upper half to produce an impression of water, and sometimes in pots of grey jasper or shokhan; a whole series of dwarf cactuses with flowers (see design sketch on p. 64) was particularly successful. Many of these

Wild Roses, detail. Fabergé, St. Petersburg, c. 1900. Brilliant diamonds surrounded by gold stamens form the centers of these pink enameled flowers with gold stems and nephrite leaves. The Royal Collection, Her Majesty Queen Elizabeth II

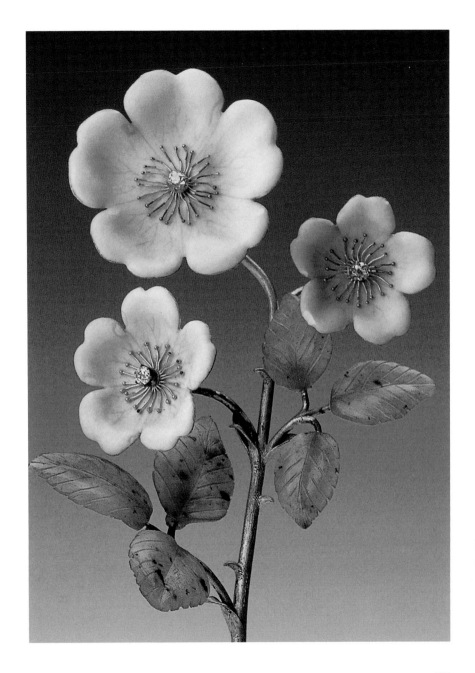

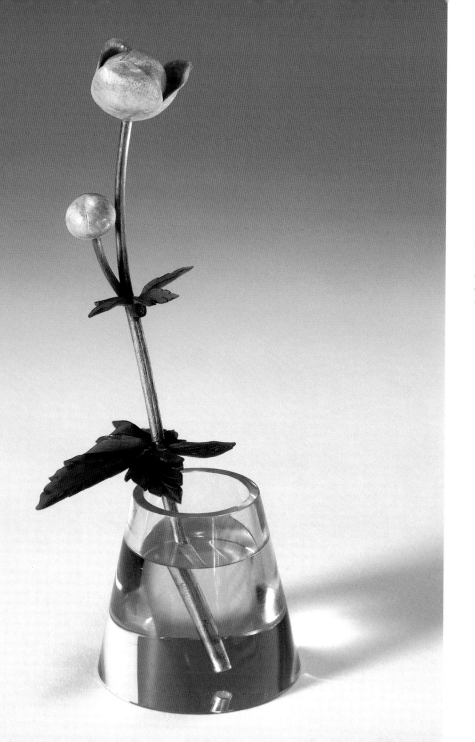

Buttercup Spray. Fabergé, Workshop of Henrik Wigström, 1908–1917. Gold, enamel, nephrite, rock crystal. With its original fitted case. Height 5¾ in. Marks: *H.W.* for Henrik Wigström; *72*, Russian gold mark, assay mark of St. Petersburg. National Museum, Stockholm

The bud and partially opened flower of translucent yellow enamel with leaves of carved nephrite on a gold stem stand in a rock crystal vase with carved water.

works were purchased by the Grand Duchess Marie Pavlovna or given to her by friends or relatives."[5]

Grand Duchess Marie Pavlovna, (below) wife of the Tsar's uncle, Grand Duke Vladimir Alexandrovich, had thirty-four Fabergé flowers—the largest known collection—according to an inventory made of the objects in her palace on the Neva in 1917 (see p. 113). Although this collection was dispersed and largely lost after the revolution in 1917, the Narcissus, Sweet Pea, and Blueberry now in the State Hermitage Museum (pp. 32, 41) were acquired from the antiquarian A.K. Rudanovsky, and, as Valentin Skurlov explains in his essay (p. 103), were most likely in her original collection at the Vladimir Palace. Curators today describe how the Grand Duchess's Fabergé objects were placed around the palace drawing rooms which are architecturally intact. [6]

Grand Duchess Marie Pavlovna (1854–1920). Grand Duchess Vladimir, as she is known formally, was born a German princess of the Mecklenburg-Schveren dynasty. She married Grand Duke Vladimir Alexandrovich, brother of Emperor Alexander III. As hostess of elegant balls and salons, she tried to play the role of "first lady" of the Empire. Her collected treasures, including her Fabergé collection, outshone those of other members of the Romanov dynasty. Private Collection

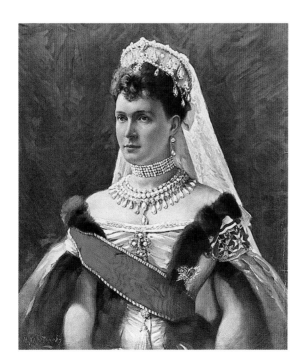

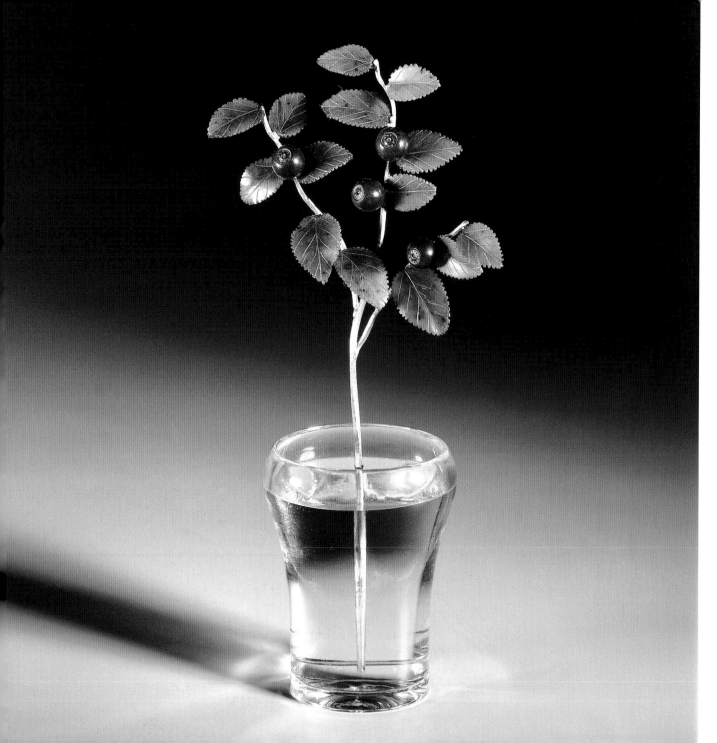

The Fabergé flowers were displayed for the first time in Paris in 1900, at the *Exposition Universellem,* when objects from the collections of the two Russian Empresses, Marie Feodorovna and Alexandra Feodorovna, were included in the Fabergé display pavilion. Birbaum describes the reaction in his memoir:

> When our enameled flowers were first displayed at the Paris
> Exposition of 1900, they were immediately copied by German and
> Austrian manufacturers and the market was flooded with cheap
> versions—lacquers instead of enamels and glass instead of rock
> crystal in vases.[7]

This was certainly the beginning of the line of "Fauxbergé" (as Geza von Habsburg has termed it) flowers and other Fabergé objects. Nevertheless, the Fabergé display in Paris was so acclaimed that there was a demand for an exhibition in Russia. In March 1902 a charity exhibition entitled *Artistic Objects and Miniatures by Fabergé* was organized under the patronage of Empress Alexandra Feodorovna and included art objects belonging to members of the Imperial family as well as to the nobility and aristocracy of St. Petersburg. Held at the von Dervis mansion on the Neva embankment, it was the only exhibition of Fabergé art objects in Russia before the revolution. The objects belonging to the two Empresses and other members of the Imperial family were displayed in pyramid-shaped cases provided by the Hermitage and are still in use there today. (p. 42) The prominent St. Petersburg photographer, Bulla, photographed the exhibition with all of its cases, providing a unique document of the Russian Imperial collections of Fabergé up to 1902. Some of the objects are recognizable in museum collections today, but others, now lost, can only be seen in these photographs.

The egg filled with an exquisite basket of spring flowers (p. 43, right) seen on the bottom shelf (p. 45) was an Easter gift to Empress Alexandra from Nicholas II in 1901. Now in the British Royal Collection, it was identified as an Imperial egg (see p. 94) when these photographs were first published more than a decade ago. The egg contains one of the few floral bouquets made in the Fabergé workshops. A magnificent single

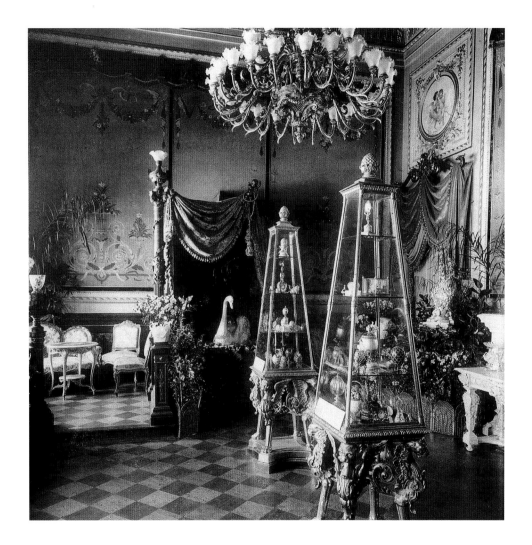

Pyramid-shaped cases displaying the Fabergé collections of the two Russian Empresses, Marie Feodorovna, mother of Nicholas II, and Alexandra Feodorovna, wife of Nicholas II, at the charity exhibition of 1902 held at the von Dervis mansion in St. Petersburg. An abundance of fresh flowers can be seen around the room. Photo courtesy of the State Hermitage Museum, St. Petersburg

The new young Tsar, Nicholas II, with his bride, Alexandra Feodorovna, photographed in a floral setting in St. Petersburg, c. 1898. Private Collection

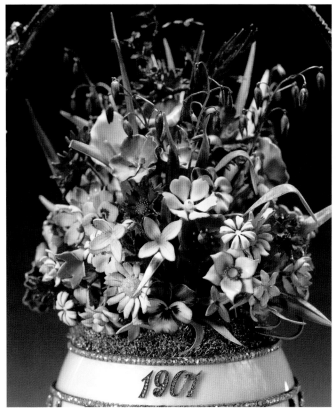

The Basket of Flowers Egg, given by Nicholas II to Empress Alexandra in 1901, which can be seen on the bottom shelf of her pyramid case (p. 45). It was bought by Queen Mary in London in 1933 and is now in the British Royal Collection (see pp. 41, 94). The Royal Collection, Her Majesty Queen Elizabeth II

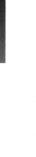

rose set in a simple rock crystal vase, unique among the Fabergé flowers, can be seen nearby. It does not appear on the list of flowers purchased by the Emperor or Empress (see p. 108). Who gave it to her, on what occasion? Where is it now? Also seen in this case is the Lilies of the Valley egg (p. 46) presented by Nicholas II to the Empress Alexandra in 1898 and now in the Forbes Collection in New York. To the left, the Clock Egg can be seen, Nicholas's Easter gift of 1899 (p. 47, left). On top of the egg is a superb bouquet of white chalcedony lilies with gold leaves and stems. The center of each flower is set with rose-cut diamonds (p. 47, right). Now in the collection of the Kremlin Museums, this is one of the few Imperial eggs to have remained in Russia.

Barely seen on the bottom shelf is the Basket of Lilies of the Valley considered to be the most beautiful of all the Fabergé flowers (p. 49). Lilies of the valley were the favorite flower of Alexandra Feodorovna, which is undoubtedly why they were such a frequent theme in the work of Fabergé. The Basket of Pearl Flowers closely resembles a photograph of a Basket of Lilies of the Valley in a Fabergé album preserved at the Fersman Mineralogical Institute in Moscow, from which it may have been modeled. It is one of the earliest of the Fabergé flowers, dated 1896 in an inscription underneath the basket, and was presented to the newly crowned Empress by Siberian industrial leaders exhibiting at the famous Nijny Novgorod Fair when the young couple visited shortly after their coronation in 1896. A bouquet of flowers was the traditional presentation according to the Russian custom, but this exquisite Fabergé creation was a unique gift for the occasion. Industrialization was beginning to accelerate in Russia during the reign of Nicholas II, and this imaginative gift reflects the growing importance of the emerging merchant class so soon to be destroyed following the revolution in 1917. According to a Fabergé interview of 1914, the Basket of Lilies of the Valley was a favorite of the Empress, who "always kept it on her writing table"[8] in the Alexander Palace at Tsarskoe Selo, the family home of the last tsar.

On the bottom shelf, to the left of the Basket of Flowers Egg, a rock crystal vase holding two tall flowers is visible. Its whereabouts today is unknown. A large Bleeding Heart is set on the top shelf of another pyramid case (not shown here) displaying the collection of Grand Duchess Elizaveta Feodorovna, sister of the Empress. This and several other little flowers in vases can be seen in these cases, all of them unknown

Close-up view of the display case containing Empress Alexandra's collection of Fabergé exhibited in 1902. The Basket of Flowers Egg can be seen on the lower right. Just above it is the Lilies of the Valley Egg, and to the left is the Clock Egg with a bouquet of lilies. Just below is seen a Rose in a rock crystal vase. The whereabouts of this piece is unknown today. Photo courtesy of the State Hermitage Museum, St. Petersburg

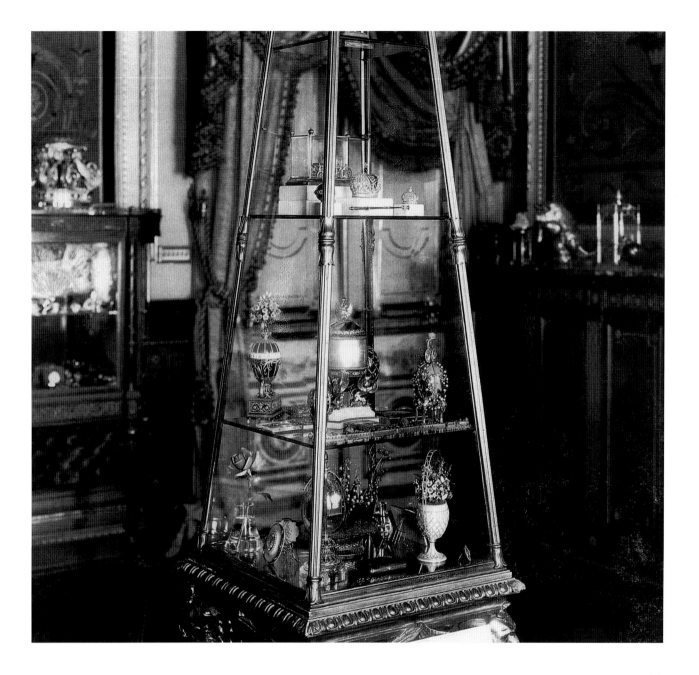

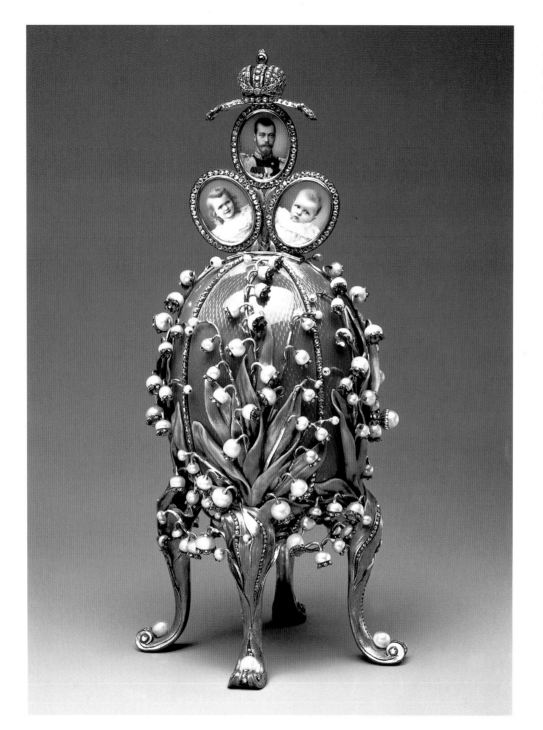

The Lilies of the Valley Egg in Art Nouveau style, given by Nicholas II to Empress Alexandra in 1898 (see p. 44). Formerly, the Forbes Collection, New York

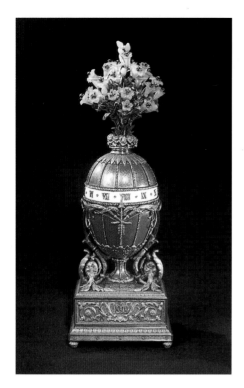

ABOVE, LEFT
The Clock Egg with a bou-
quet of lilies, given by
Nicholas II to Empress
Alexandra in 1899
(see p. 44). State Museums
of the Moscow Kremlin

ABOVE, RIGHT
The bouquet of white chal-
cedony lilies with gold
leaves and stems atop the
Clock Egg.

today. These rare photographs are the only known views of flowers in the Russian Imperial collections.

Flowers were an important part of Russian society and the court culture in St. Petersburg beginning in the eighteenth century, soon after the founding of the city by Peter the Great in 1703. European styles of art, architecture and interior decoration were adopted and synthesized into Russian fashion by Peter's successors, particularly the Empresses Elizabeth, his daughter, and Catherine the Great, the German bride of his great-nephew. The halls and galleries of St. Petersburg palaces were transformed into tropical conservatories for balls and official receptions with masses of fresh flowers—palm trees, myrtles, and camellias in full bloom—brought in the morning on sleighs from the imperial greenhouses.

Glass conservatories filled with greenery and a variety of flowering species, some of exotic origin, became popular in wealthy residences by the end of the eighteenth century. By the middle of the nineteenth century, cut flowers and flowering plants were prominent in the homes of all classes. Theophile Gautier, traveling in Russia in 1865, noted in his journal the profusion of "flowers, a true Russian luxury." He described "magnolia and camellia trees flowering near gilded ceilings" and "cornucopias of exotic flowers." "Every apartment is a hothouse," he recorded.[9]

There were one hundred florists in St. Petersburg in the time of Fabergé, some of them specializing in the express train service from Paris and Nice that brought flowers to the palaces of St. Petersburg (see p. 103). Flowers were an important presentation for every occasion in Russia—birthdays, anniversaries, namesdays, Easter and other holidays, as well as arrivals and departures.

Sometimes flowers were the medium of a grand *beau geste*, as when Princess Elizabeth of Hesse and by Rhine was travelling to St. Petersburg for her wedding in 1884 to Grand Duke Serge Alexandrovich, brother of Alexander III. When her train stopped at the Russian border, Grand Duke Serge had each car decorated with the scented white flowers that she liked so much.[10] This gesture was more significant in its symbolism than he might have imagined, for Elizabeth's younger sister, Princess Alix, was also on the train and would meet her future husband, the Tsarevich Nicholas Alexandrovich, at that wedding, and become the last Empress of Russia.[11]

Botanical books, treatises on the "language" and symbolism of flowers, flower painting and drawing, and fresh flowers in the home were all extremely popular in the nineteenth century, in the United States and Europe, as well as in Russia. Drawing and painting flowers was part of the education of young ladies of good family, including all of the daughters of the Russian Imperial family. Some of them were quite talented, such as Grand Duchess Olga Alexandrovna, the youngest daughter of Alexander III and Empress Marie Feodorovna. Flowers in nature were a dominant theme in her watercolors, which are becoming increasingly popular in the art world today. Her nieces, the Grand Duchesses Olga, Tatiana, Marie, and Anastasia, also painted many charming watercolors of flowers, often accompanied by loving good wishes to their

The Imperial Basket of Lilies of the Valley presented to the Empress Alexandra in 1896. It was one of her favorite pieces. New Orleans Museum of Art, Matilda Geddings Gray Foundation Loan

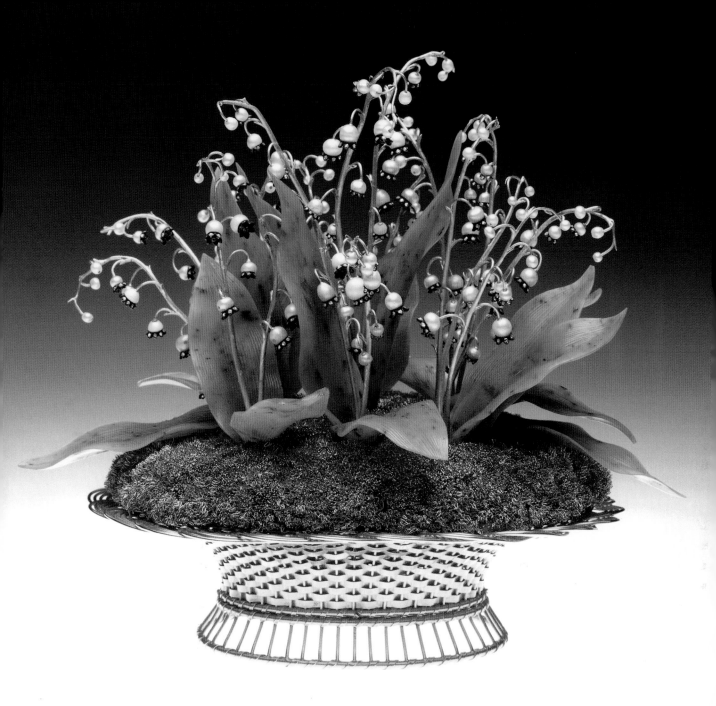

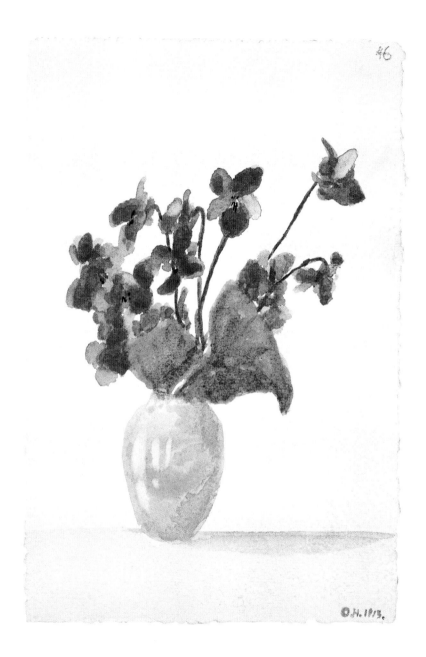

O.N. 1913.

A watercolor drawing of spring violets by Grand Duchess Olga Nikolaevna, 1913. State Archive of the Russian Federation

mother or grandmother for a birthday or namesday. (p. 50) Little Grand Duchess Olga Nikolaevna sent a charming flower note to her grandmother, the Dowager Empress Marie Feodorovna for her namesday on July 22, 1903: "I'll pick a bunch of flowers for your namesday, lots of motley, fragrant flowers—wild roses and sweet smelling jasmine and some wide maple leaves too . . ."[12]

The young Grand Duchesses sometimes pressed flowers into their albums and special books, which are still preserved today. Pansies found inside Grand Duchess Tatiana's little leather-bound book of the services of Easter week have even retained their natural colors.

Unique among the Fabergé flowers is the mechanical Pansy (Cupid's Delight) of 1904, presented to Alexandra Feodorovna on the occasion of her tenth wedding anniversary. The gold flower is enameled in natural pastel colors (p. 52) and opens up when a button on the stem is moved. Inside the flower are five miniature portraits of Nicholas and Alexandra's children, each one framed in tiny rose-cut diamonds (p. 53). The names of the children—Olga, Tatiana, Marie, Anastasia, and Alexis—are engraved on the rock crystal vase along with the Roman numeral X indicating ten years. The pansy is a fall/winter flower, appropriate to commemorate the wedding of Princess Alix of Hesse and by Rhine and the new young Tsar, Nicholas, which took place in the Great Church of the Winter Palace on November 14 (November 26, according to the Julian calendar used in Russia at the time), 1894. Along with the diamond nuptial crown and kokoshnik (Court headdress), the bride wore a small wreath of scented white orange blossom brought from the Imperial conservatory in Warsaw.[13] Orange blossom[14] was traditionally worn by brides as a symbol of purity and loveliness.

At Easter of 1895, soon after their wedding, Alexandra Feodorovna received a Fabergé enameled Easter egg from her new husband (p. 55). Inside was the "surprise," an enameled yellow rose, which opened to reveal a further surprise, a miniature replica of the Russian Imperial crown, now lost.

Empress Alexandra loved flowers, which can be seen in many photographs of her in the family's albums (p. 95). Baroness Sophie Buxhoeveden, lady-in-waiting to the Empress, describes in her memoirs that "Her rooms were always a mass of white lilac

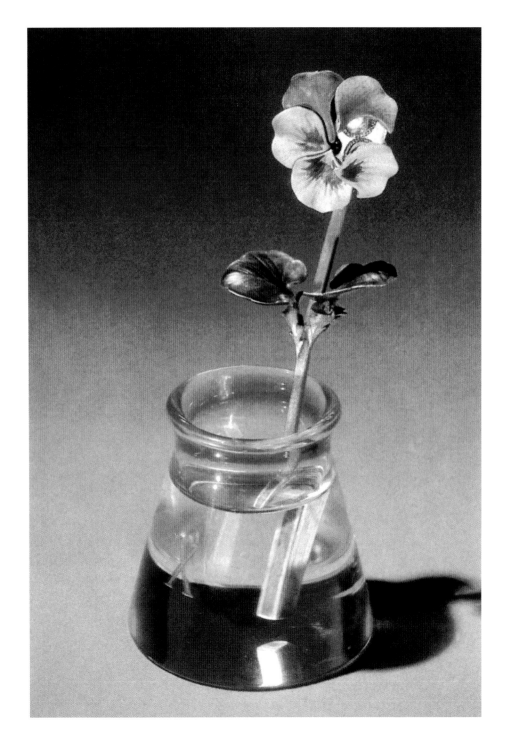

LEFT
Wild Pansy, a tenth wedding anniversary gift of Nicholas II to Empress Alexandra in 1904 (see p. 51). State Museums of the Moscow Kremlin

OPPOSITE
By means of a small knob on the stem, the petals of the pansy open to reveal miniature portraits of the five children surrounded by rose diamonds. State Museums of the Moscow Kremlin

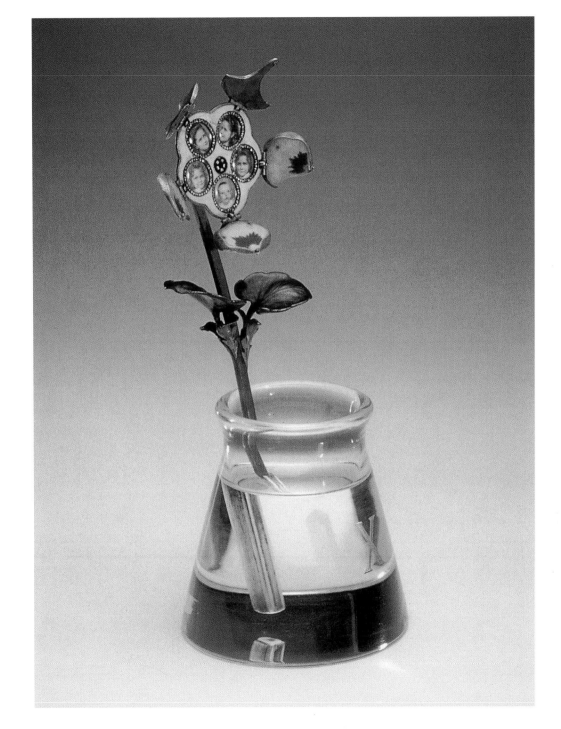

and every kind of beautiful orchid. And they flourished," she added, "for the Empress's rooms were always cold in the English manner. Like her grandmother, Queen Victoria, she couldn't stand a temperature that was moderately warm."[15] Although the Empress' favorite flower was known to be lily-of-the valley, she "loved all flowers, her special favorites being lilies, magnolias, wisteria, rhododendrons, freesias, and violets,"[16] as her friend Lili Dehn noted in her memoir.

Flowers were prominent at Livadia, the Italianate villa in the Crimea built by Nicholas II in 1911 and much loved by the family as a vacation home. In addition to wildflowers "bought from the local Tatars," there was " a whole sea of roses"[17] around the estate, which were enjoyed by Nicholas himself. His words of satisfaction were recorded by the gardener: "What wonderful roses you have, so charming, such a mass of them, a whole sea."[18] There was also a greenhouse at Livadia from which fresh flowers would be sent to Tsarskoe Selo for the Empress's rooms at the Alexander Palace. During the war years of 1915–1916, the Empress would have flowers sent from Livadia to Stavka, the Allied Military Headquarters at Mogilev. "The Emperor told me," wrote Sir John Hanbury-Williams, Chief of the British Military Mission, "that she sent him flowers every day for his room."[19]

OPPOSITE

Rosebud Egg presented by Nicholas II to Empress Alexandra at Easter of 1895, the first of her Fabergé eggs (see p. 51). Formerly, the Forbes Collection, New York. Photographer: Joseph Coscia, Jr.

LEFT

A present-day view of Livadia, the Italianate villa near Yalta in the Crimea, built by Nicholas II in 1911. The gardens were maintained for many years just as they were in the time of the Romanovs. The Yalta Peace Conference took place at Livadia in 1945. President Roosevelt was housed here.

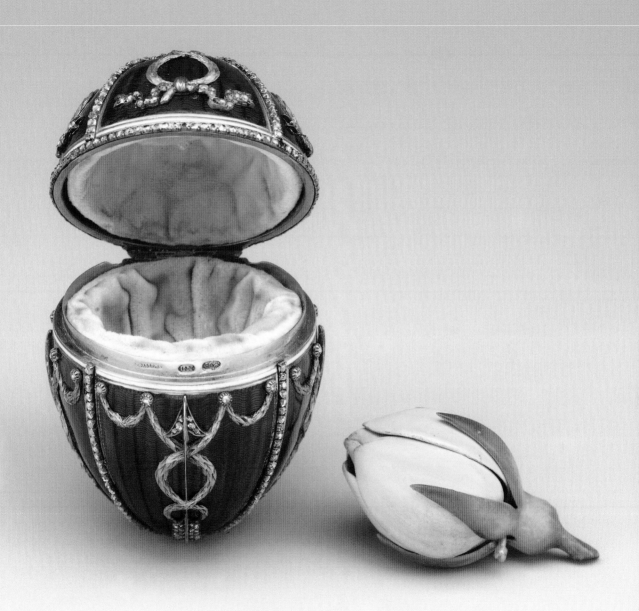

The Empress and her daughters all used Coty floral scents. "White Rose," created for Queen Victoria in London in the early nineteenth century, was a favorite floral scent of Empress Alexandra. The Grand Duchesses always used the Coty floral perfumes: Olga preferred "Rose Thé," Tatiana favored "Jasmin," Marie used "Lilac," and Anastasia liked "Violette" best.[20]

These and other popular flowers of the time—hawthorn, margarita and cornflower—were among the varied specimens created in the Fabergé workshops. (see pp. 2, 10, and 21). Carl Fabergé was finely tuned to the cultural world around him and the flowers remain today a rare artistic legacy of Imperial St. Petersburg—"a thing of beauty" and "a joy forever."

Cherries, Lily of the Valley, and Primula. Fabergé, c. 1900. Cherries: gold, purpurine, nephrite, rock crystal; Lily of the Valley: gold, pearls, rose diamonds, nephrite, rock crystal; Primula: gold, enamel, nephrite, rock crystal. Height of Lily of the Valley 8 in. All unmarked. Wartski, London

The Lily of the Valley was originally in the collection of Mme. Elizabeth Baletta, actress of the Imperial Michel Theatre in St. Petersburg. She was a favorite of the Grand Duke Alexis Alexandrovich, who gave her many Fabergé gifts, especially animals and flowers.

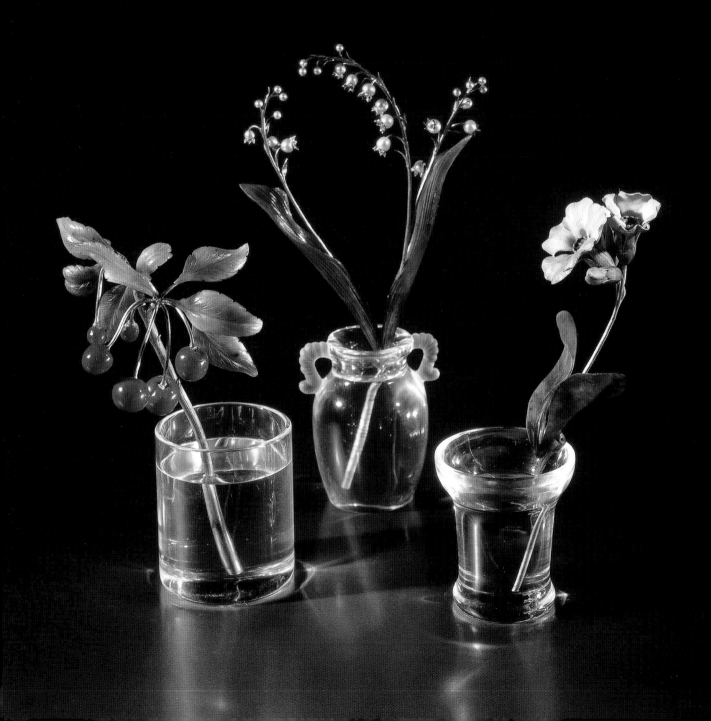

NOTES

1. Boris Pasternak, *Safe Conduct.*

2. Franz. P. Birbaum, *The History of the House of Fabergé, According to the Recollections of Franz P. Birbaum,* St. Petersburg, 1992, 43.

3. *Town and Country, A Journal for Gracious Living,* St. Petersburg, no. 2 , 1914, 14.

4. M. Paleologue, *An Ambassador's Memoirs,* Vol. 1, New York, 1925, 14.

5. Birbaum, 43.

6. The Vladimir Palace on the Neva embankment became a club for scientists almost immediately after the revolution and up to the 1990s. It was reasonably maintained and basically unaltered. Many of the original furnishings and decoration remain intact today.

7. Birbaum, 43.

8. *Town and Country,* 14.

9. Charlotte Gere, *Nineteenth-Century Decoration, The Art of the Interior,* New York, 1989, 107.

10. Lubov Millar, *Grand Duchess Elizabeth of Russia,* Redding, California, 1991, 25.

11. In retrospect, there is remarkable symbolism in this little vignette as both sisters eventually became martyrs in 1918 and are now canonized saints of the Russian Orthodox Church. Many flowers are placed in churches today where there are icons of the Royal Martyrs.

12. Grand Duchess Olga copied this poem written by the Tsar's cousin, the Grand Duke Konstantine, the noted poet known in literary circles as "KR." His work is becoming better known in Russia today. State Archive of the Russian Federation, Collection 642, File 1, D 2435, FUND 642, op1.

13. G.C. Munn, *Tiara, A History of Splendour,* England, 2002, 281.

14. There is a lovely Fabergé sprig of orange blossom (Philadelphus) in the British Royal Collection.

15. S. Buxhoeveden, *The Life and Tragedy of the Empress Alexandra Feodorovna,* London/New York/Toronto, 1928, 52.

16. L. Dehn, *The Real Tsaritsa,* Boston, 1922, 71.

17. A.V. Popov, *The Romanovs on the Southern Shore of the Crimea,* Crimea, 1930, 59. Reference provided by Valentin V. Skurlov, St. Petersburg.

18. Popov, 60.

19. J. Hanbury-Williams, *The Emperor Nicholas II as I Knew Him,* London, 1922, 93.

20. Dehn, 79.

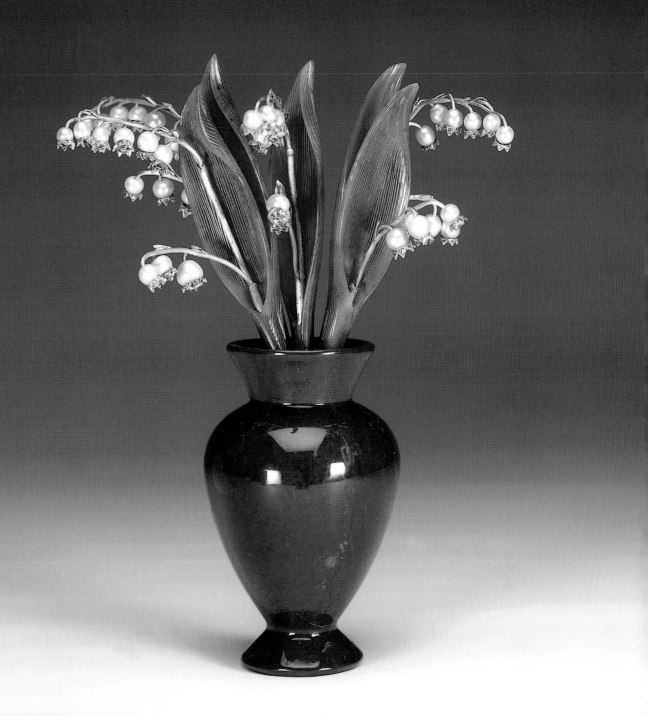

Pear Blossom. Fabergé, c. 1900.
Gold, silver, enamel, diamonds,
nephrite, rock crystal. Height 5⅞ in.
Unmarked. The Board of Trustees of
the Queen's Own Warwickshire and
Worcestershire Yeomanry

A chased and engraved gold twig
of six flowers, enameled white with
shades of pale pink, stands in a
rock crystal vase with carved water.
Each flower is centered with oxi-
dized silver stamens and a brilliant
diamond, and surrounded by veined
leaves of carved nephrite.

The vase is engraved with the
inscription *Q.O.W.H. South Africa
1900* and encircled by a chased
green-gold laurel leaf wreath tied
with a red bow.

This jeweled pear blossom was pre-
sented by the Countess of Dudley,
a customer of the London branch
of Fabergé, to the Queen's Own
Worcestershire Hussars in the early
1900s as a regimental trophy. On
February 7, 1900, a squadron of vol-
unteers from the regiment sailed
for South Africa, as part of the
Imperial Yeomanry. The Countess
of Dudley, wife of the commanding
officer, gave every soldier a sprig of
pear blossom, worked in silk to be
worn in the hat. Later she gave the
regiment this unique jewel that has
passed down through successive
regiments and is now part of the
collection held by The Queen's Own
Warwickshire and Worcestershire
Yeomanry Charitable Trust.

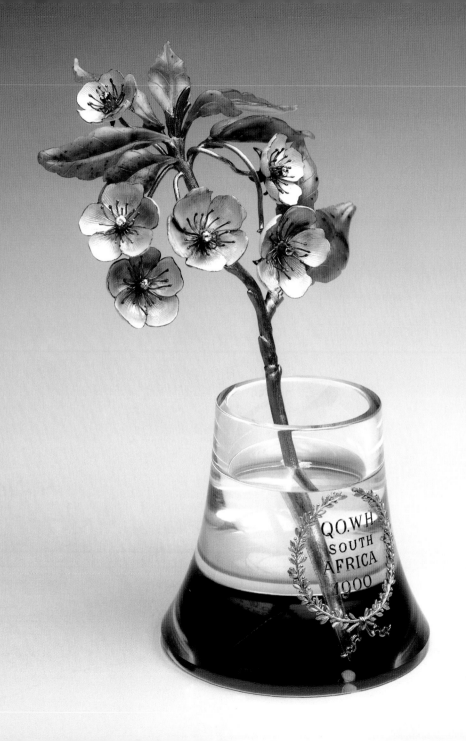

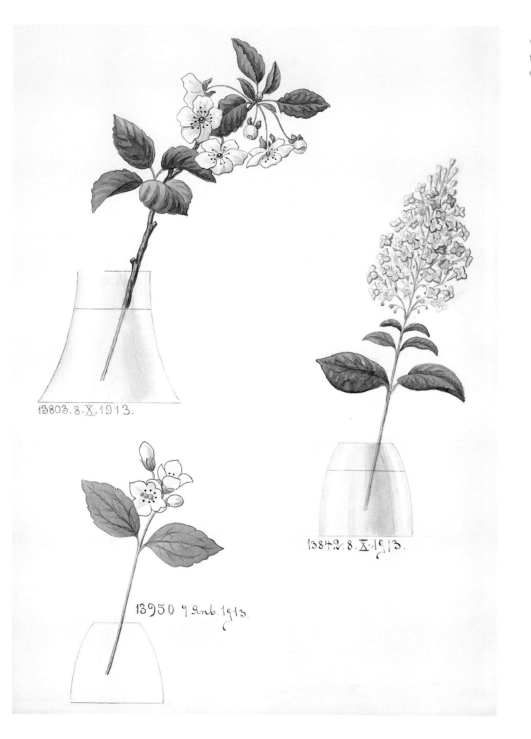

13803. 8. X. 1913.

13842. 8. X. 1913.

13950 9 Янв. 1913.

Watercolors of flowers from the recently discovered Fabergé album

An Astonishing Discovery Ulla Tillander-Godenhielm

An Album of designs from the House of Fabergé with two pages of delightful botanical studies has recently been discovered. Drawings of the hardstone flowers produced in the Fabergé workshops are exceedingly rare. With one other exception, these are the only ones to have survived.[1]

The designs originated in the workshop of the master goldsmith Henrik Wigström. From 1903 until the demise of the Russian Empire in 1917, Wigström's workshop was the principal one in the House of Fabergé. It was this atelier that produced the majority of Imperial Easter eggs, as well as most of the official commissions and other exceptional orders placed by Fabergé's prestigious clientele. The Wigström Album provides no written information about the flowers other than that they were completed between 1913 and 1916.

To whom these flower creations were sold remains a mystery, and their current whereabouts is unknown. Carl Fabergé's elegant shop was located in the historical center of St. Petersburg, which was in the midst of the turmoil of war and revolution. Records and ledgers disappeared with the closing of his workshops in 1918. It is hoped that these ledgers will one day emerge and more information will come to light.

The Album designs, however, speak for themselves; the flowers are drawn in their actual size and painted in watercolor in such minute detail that it is possible to determine the materials used in making them. The hardstones in which they were sculpted

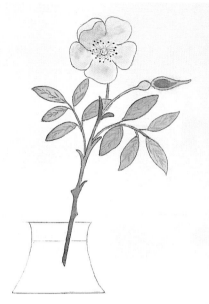

15590. Egану

15308. 10ᵉ Мая 1916г.

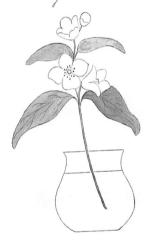

15659. Egану

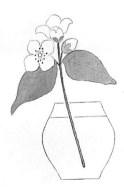

15660. Egану

LEFT
Watercolors of flowers and cactus from the recently discovered Fabergé album, including a mock orange

OPPOSITE
Mock Orange. Fabergé, Workshop of Henrik Wigström, 1911–1916. Gold, snow quartz, nephrite, rock crystal. Height 5⅝ in. Unmarked. Private Collection

The original drawing of this scented spring blossom from the Wigström Workshop was only recently discovered and is published here for the first time (left).

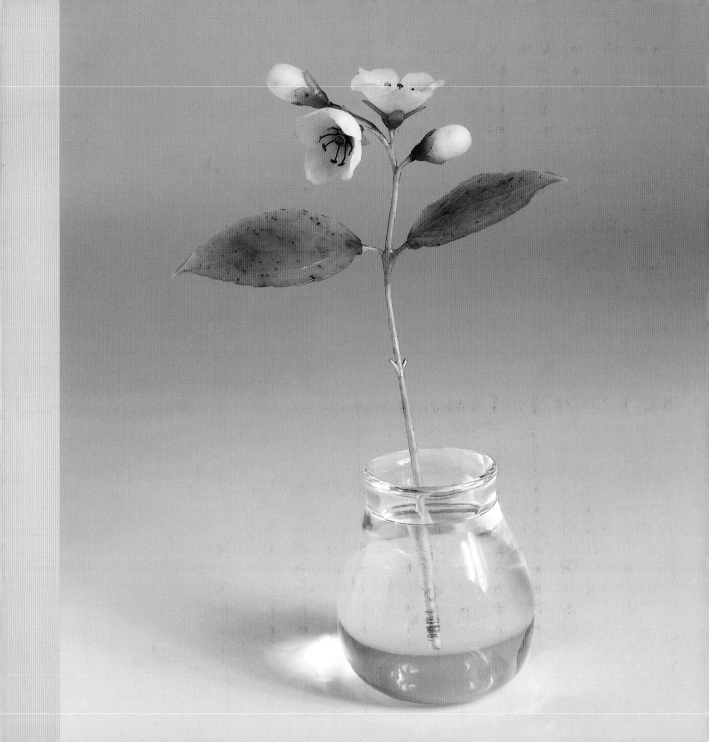

can be easily identified. One perceives the nuances of the skillfully applied enamel, the tiny gemstones set in the flower heads to enhance their beauty and the precious metal alloys used for the stems, anthers, and pistils.

All but one of the drawings are of flowers well known to the inhabitants of European Russia. They blossom in spring and early summer during the White Nights when the sun sinks below the horizon for just a few hours.

One drawing is of a sprig of cherry blossom, another a dainty pansy, a third a fragrant white lilac and a fourth a branch of the fragile wild rose. There are three small branches of mock orange, indicative of the love of Russians for this opulent flowering bush. In former times, in the region of St. Petersburg during the early part of July, the intoxicating scent of the mock orange filled the gardens and wafted through the open windows of dachas and estates.

One of the plants on these two pages of designs does not seem to belong: a small cactus with a red flower, the species of which is difficult to identify. Its presence, however, is an indication of the popularity of cacti in Russian interior decoration in the early twentieth century.

The discovery of the drawings leads to the question of how they were made, which materials were used, and what specimens of flowers and plants the craftsmen at Fabergé chose to fashion. In fact, the flower studies were the result of teamwork among four different, highly specialized ateliers of the House. Work on a flower study began in the artist's studio. The designer worked with both the actual flowers and botanical encyclopedias containing graphic details.[2] The head of the House, Carl Fabergé himself, then looked at the designs and, together with his closest collaborators, decided which ones to realize.

The approved designs were then sent to the atelier of the senior workmaster Henrik Wigström, whose workshop was on the second floor of the production wing of the Fabergé business complex. Wigström, a highly skilled Finnish-born master goldsmith, was responsible for the craftmanship and quality of the finished product. The symbol of this responsibility was his personal master's mark H.W. stamped on the completed object. Together with his leading goldsmith and mounter, Wigström exam-

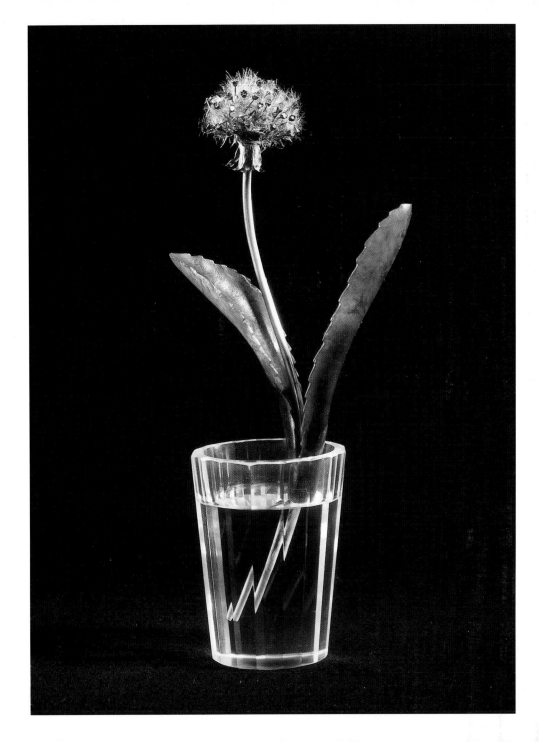

Dandelion. Fabergé, Workshop of Henrik Wigström, 1903–1917. Gold, nephrite, diamonds, rock crystal, fluff. Height 6¼ in. Marks: *H.W.* for Henrik Wigström; *Faberge* in Cyrillic letters. Christie's Images, Ltd. 2000

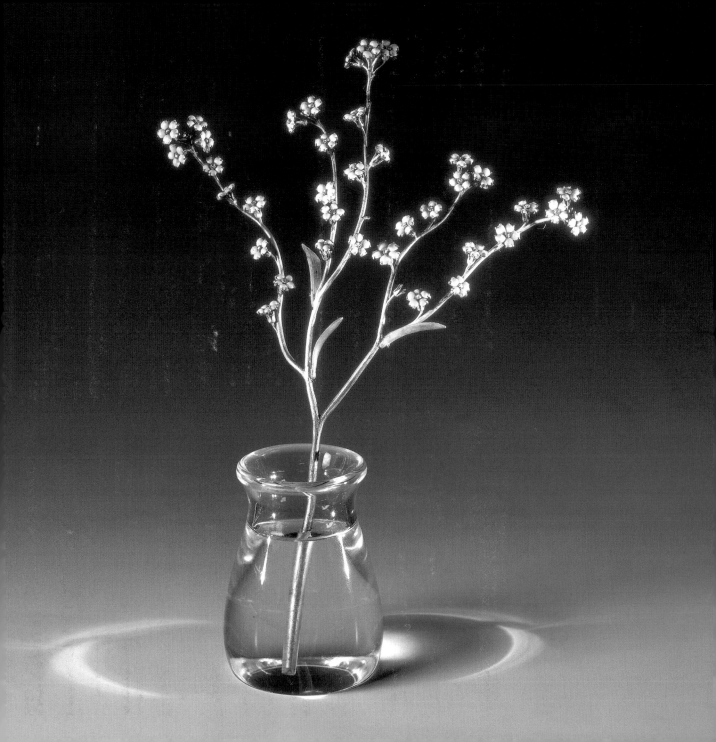

Forget-Me-Not. Fabergé, c. 1900. Gold, enamel, turquoise, rose diamonds, rock crystal. Height 4¼ in. Unmarked. Wartski, London

A spray of turquoise forget-me-nots with rose diamond centers stands in a rock crystal vase carved to simulate the appearance of water. Several translucent green enameled leaves appear on the realistically engraved gold stems. There are several Fabergé versions of this summer flower. This piece was once in the collection of Lady Zia Wernher, daughter of Grand Duke Mikhail Mikhailovich, at Luton Hoo, England.

A Fabergé watercolor of a forget-me-not

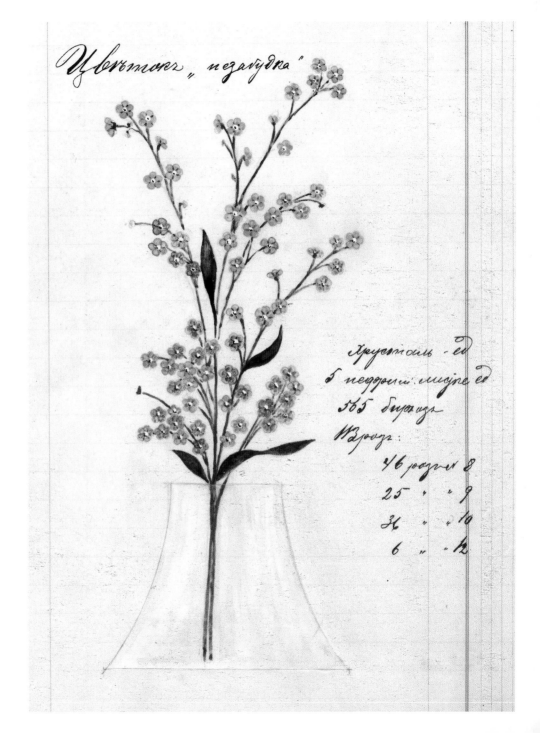

ined the artist's design, studied its technical details, decided how the object would be made and of what precious metals and stones, and tried to anticipate any possible problems that might arise from assembling the various parts. Small adjustments to the artist's design were still possible at this early stage of the work.

The next step for Wigström was to hold a round-table discussion with the head of the stone-carving workshop, located in Angliskii Prospekt a few blocks away from Fabergé's main workshops. At the time in question, Fabergé's head stonecutter was Peter Mikhailovich Kremlev, a man of peasant stock who had learned his craft at the Ekaterinburg School of Art and Industry in Siberia.[3] Kremlev personally, and with great care, selected the specimens of hardstone to be used for each specific work, then submitted these in semi-rough form for approval first to Carl Fabergé and his designer, and then to Wigström.

Russia possessed a wealth of hardstone in the Ural Mountains and across Siberia as far as the Altai Mountains close to the border of China. For the flower studies, as for most objets d'art involving hardstone, these indigenous materials were used to the greatest extent possible.

Transparent rock crystal was the obvious material for the vase into which the stem of the flower was placed. The designers chose a variety of shapes, but always very simple ones so as not to detract attention from the flower itself. At first glance the vase appears to be half-filled with water, but upon closer inspection this amazing *trompe l'oeil* effect is the result of the stonecutter's craft. He cuts the container from a single block of rock crystal, complete with the "water."

The petals of white flowers, such as cherry and apple blossom, mock orange and wood anemones, were cut in snow-white quartz, which exquisitely imitated nature. For red flowers or berries, such as bleeding heart or raspberry, intense rose specimens of rhodonite with minute black veins or white spots were perfect. There were large deposits of rhodonite in the Urals and this lovely stone acquired such an immense popularity that it came to be considered Russia's national stone.

Where a deeper red was required, to imitate a ripe cherry for example, the vitreous compound called purpurine was used. Purpurine, produced by crystallizing lead chro-

mate in a glass matrix, was manufactured by the Imperial Glass Factory of Russia. This was the only man-made material used in the production of the flowers. The dainty bells of the lily of the valley were composed of small pearls, the forget-me-nots were crafted in turquoise, the cluster of diminutive flowers on a sprig of lilac was cut from either mauve amethyst quartz or creamy white quartz. One marvel of creation was the dandelion pappus, the joy of every child but a nightmare for every gardener. Bunches of the actual parachute-like seeds of the dandelion were attached by the finest possible gold wire topped with minute rose-cut diamonds, thereby producing a wonderful effect and, in the words of Fabergé's designer Franz P. Birbaum, "saving these artificial flower studies from any excessive imitation of nature."[4]

The foliage of the plants was cut in the fine translucent mottled green of Siberian nephrite, astonishingly close to nature's various leaf shades. The cutter enhanced the effect by engraving fine veins on the leaves, and even repeating them on the side underneath. Nephrite, which Fabergé used extensively in his products, was found in gigantic boulders near Lake Baikal in Siberia and the Sayan Highlands along the River Onat in the eastern part of the Altai Mountains on the border of Mongolia.

When the stonecutter had completed his work, the construction of the metal parts and the assembling of the entire object took place at Wigström's. The stem of the flower was crafted in an alloy of gold that as closely as possible simulated the natural colour of a stem; either gold alloyed with copper to make it brownish red, or gold alloyed with silver to make it greenish. The rough-textured skin of the stem was achieved with the aid of engraving and embossing tools. The sharp thorns on the branch of a wild rose were soldered to the stalk and given an oxidized patina. The foliage was anchored to the stem either with minute gold pins or set into small pockets of the leaves and secured with a special glue. If they had been made in separate parts, the petals of the flowers were then assembled and furnished with anthers and pistils from the finest possible gold thread trimmed to the correct length.

In those cases where hardstones or precious metals were unable to imitate the colors of nature, Fabergé's skilful enameler would take over, and it is for this reason that this workshop played a vital role in the work of flower studies. The gold-crafted flower

heads of violets and pansies, the petals of roses, buttercups, cornflowers and daisies, were enameled by the master enameler Nikolai Alexandrovich Petrov, with the assistance of his brother Dmitri. Unlike the other workmasters, Petrov carried out the most demanding work himself. The pressure on this workshop must have been enormous: for of the objects made in Wigström's workshop from 1911 to 1916, every other piece was decorated with enamel! The exquisite quality of Petrov's enameling was the product not only of superb craftsmanship, but also of tremendous patience. Enameling was an extremely demanding process, requiring the application on the gold of layer after layer of the glass substance, which was baked and re-baked until the required effect was obtained.

The finishing touches to the objects were made in Wigström's workshop. Small diamonds, most often rose cut, or minute green demantoid garnets, were set onto the pistils of the flowers or the centers of the flower-heads, the brilliance of the diamonds and exceptional luster of the olive green demantoids highlighting the flower study and providing it with an extra touch of luxury. The demantoid from the Middle Urals was the most highly prized of all the garnets. With a high refractive index and dispersion greater than diamonds, this exceptional stone imparted liveliness and fire to the object.

When looking at the flower studies illustrated in this volume, it becomes clear that it was the simple wild flowers of the meadows, fields and forests of Russia that were the preferred motifs of Fabergé and obviously also of his clients. Second come the blossoming trees and bushes nurtured in every Russian garden, such as cherry, lilac and mock orange. But the innate simplicity of the wild flowers still ranked the highest. Their very profusion during the summer months awoke, and still awakes feelings of the greatest pleasure in the eyes of the beholder.

There are numerous accounts describing the delight of the Imperial family, especially the Emperor Alexander III and his consort Marie Feodorovna, during their summer cruises in the Finnish archipelago. On land they strolled through the meadows and fields where the ladies picked bouquets of these lovely flowers to decorate the cabins on the Imperial yacht. Some still remember when, as young children of the local fishermen, they rowed out in small boats to the Imperial yacht laying at anchor

Daisies. Fabergé, c. 1900. Gold, enamel, diamonds, rock crystal. Height 4¼ in. Unmarked. Courtesy of A La Vieille Russie

Two daisies with diamond-set petals and yellow guilloche enamel centers on gold stems stand in a rock crystal pot with carved water. A similar study is in the collection of the St. Petersburg State Mining Institute (see p. 10).

beyond their islands, bringing their beloved Empress a greeting in the form of these simple flowers.

NOTES

1. This album is the second album to have survived from the workshop of Henrik Wigström. The first album was published in the year 2000. See Tillander-Godenhielm, Ulla; Schaffer, Peter; Ilich, Alice; and Schaffer, Mark. *Golden Years of Fabergé. Drawings and Objects from the Wigström Workshop.* A La Vieille Russie/Alain de Gourcuff, New York/Paris, 2000; see Snowman, A. K. Fabergé: *Lost and Found. The Recently Discovered Jewellery Designs from the St. Petersburg Archives.* Harry N. Abrams, New York, 1993, 108, for the single other drawing of a flower study, a spray of forget-me-nots.

2. Between the pages of this album from the Wigström workshop were torn-out pages from the Brockhaus and Efron Encyclopedia [Entsiklopedicheskiy slovar, 43 vols., St. Petersburg, 1890–1906] showing various insects, an indication that these accurate drawings had served as models for the designer and craftsman.

3. See Tatiana Fabergé and Valentin Skurlov, 1992. *The History of the House of Fabergé.* (Includes the memoirs of Franz P. Birbaum), Russkiye Samotsvety, St. Petersburg, 1992, 45. Kremlev worked for Fabergé from 1908 to 1917, heading the stone-carving workshop from 1915.

4. Fabergé and Skurlov, 42. For examples of dandelion with the natural fluff, see the well-preserved seed-ball in the collection of the Kremlin Armoury, Moscow, inventory no. MP–12013/1–3 and lot 73, Christie's, New York, Important Silver, Objects of Vertu and Russian Works of Art, April 20, 2000. For dandelion seed-balls made of the hairy crystals of the mineral asbestos, see Paul Lesley: *Handbook of the Lillian Thomas Pratt Collection. Russian Imperial Jewels.* The Virginia Museum of Fine Arts, Richmond, Virginia, 1960, fig. 16, catalogue no. 140, 46; and John W. Keefe, *Masterpieces of Fabergé. The Matilda Geddings Gray Foundation Collection.* New Orleans Museum of Art, New Orleans, 1993, catalogue no. XXXIX and The Brooklyn Museum, New York, inventory no. 78.129.17a-c.

Cranberry, Forget-Me-Nots, Lilies of the Valley, and Wild Rose. Fabergé, c. 1900. Cranberry: gold, chalcedony, nephrite, rock crystal, height 4½ in.; Forget-Me-Nots: silver, gilding, turquoise, rose diamonds, rock crystal, height 3½ in.; larger Lily of the Valley: gold, silver, pearls, rose diamonds, nephrite, rock crystal, height 4¾ in.; miniature Lily of the Valley: gold, pearls, nephrite, rock crystal, height 2 in.; Wild Rose: gold, enamel, silver, diamond, nephrite, rock crystal, height 4 in. All unmarked. The Cleveland Museum of Art

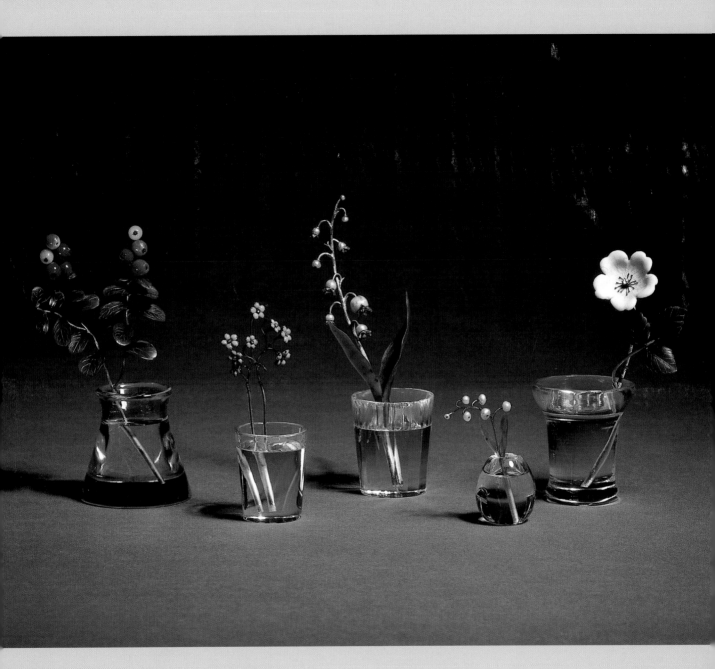

Violet. Fabergé, c. 1900.
Gold, silver, enamel,
diamond, nephrite, rock
crystal. Height 3 7/8 in.
Unmarked. The Cleveland
Museum of Art

A single violet of opaque
purple enamel with a green
enamel calyx and centered
with a brilliant diamond
set on a silver-gilt stem
with nephrite leaves stands
in a rock crystal pot with
carved water.

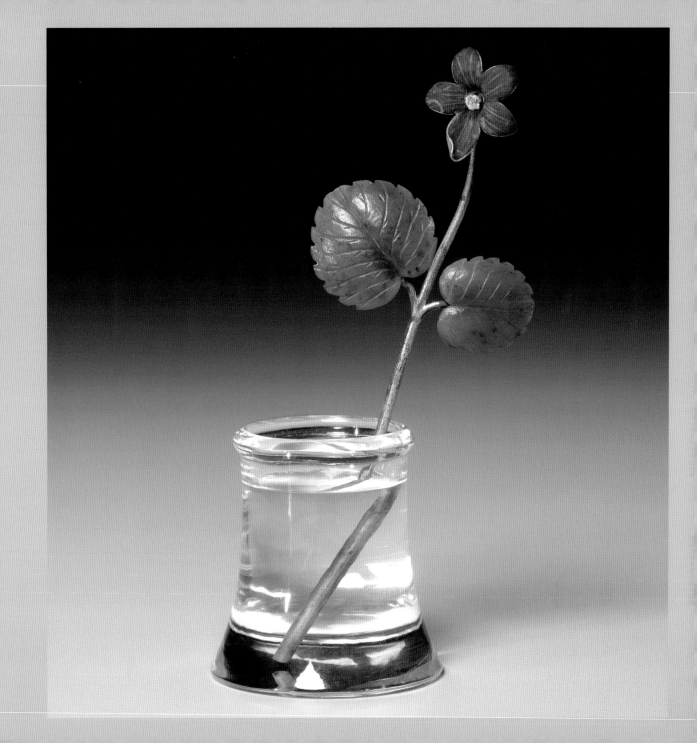

Wildflowers. Fabergé, c.
1900. Gold, rubies, chal-
cedony, nephrite, jade.
Height 5½ in. Unmarked.
Private Collection

A sprig of white chalcedony
wildflowers with gold sta-
mens, ruby centers and
nephrite sepals on a gold
stem is placed in a white
jade vase that stands on a
green Chinese jade base.

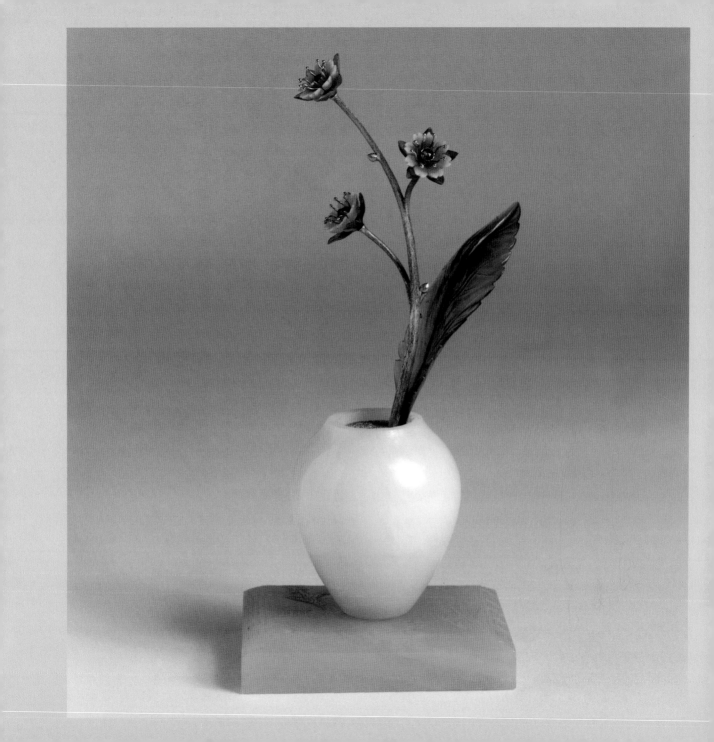

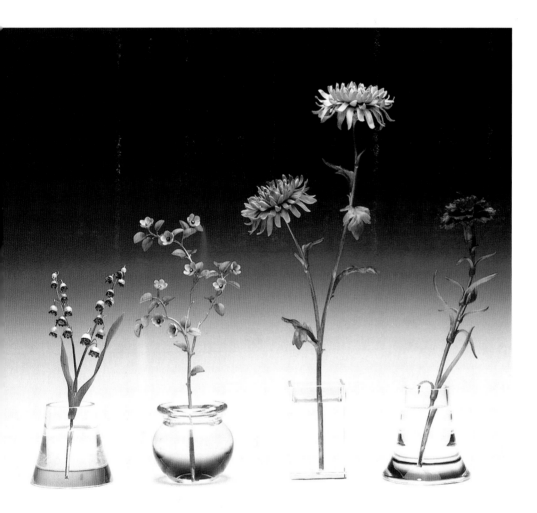

LEFT TO RIGHT

Lily of the Valley, c. 1900; Japonica, c. 1907; Chrysanthemum, c. 1908; Carnation, c. 1907. Fabergé. Lily of the Valley: gold, pearls, nephrite, rose diamonds, rock crystal, height 5¹¹/₁₆ in., unmarked; Japonica: Workshop of Henrik Wigström, gold, enamel, nephrite, rose diamonds, height 6⅝ in., marked *H.W.* for Wigström; *72*, Russian gold mark; and *Faberge* in Cyrillic letters; Chrysanthemum: Workshop of Henrik Wigström, gold, enamel, nephrite, rock crystal, height 9¹¹/₁₆ in., marked *H.W.* for Wigström; *72*, Russian gold mark; and *Faberge* in Cyrillic letters; Carnation: Workshop of Henrik Wigström, gold,

"His Greatest Patroness": Queen Alexandra and Fabergé's Flowers ~ Caroline de Guitaut

enamel, rock crystal, height 6¹⁵/₁₆ in., marked *H.W.* for Wigström; *Faberge* in Cyrillic letters. The Royal Collection, Her Majesty Queen Elizabeth II

All of these pieces are from the collection of Queen Alexandra. She bequeathed the Lily of the Valley to her daughter, Princess Victoria, from whom it later passed to the Royal Collection. The Japonica and the Chrysanthemum (the most expensive flower study sold at Fabergé's London branch) were purchased by Stanislas Poklewski-Koziell, a councilor at the Russian Embassy in London and a great friend of Edward VII, and presented to the queen.

Queen Alexandra has been described as Fabergé's "greatest patroness" and also as the greatest collector in England of his flowers.[1] In fact, she acquired twenty-two of the twenty-six flowers now in the Royal Collection. It was from her younger sister, Marie Feodorovna, who reigned in the imperial city of St. Petersburg, that Queen Alexandra received an unrivalled introduction to the work of Carl Fabergé.

Patroness and supplier were ideally suited: Queen Alexandra possessed a light-hearted spirit and a great love of nature and the outdoors, while Carl Fabergé, in his St. Petersburg workshops, created beautiful and whimsical objects, capturing the essence of the natural world and achieving a level of finish unsurpassed by any other maker at the time.

The Fabergé firm made approximately eighty known flower carvings, and the Royal Collection contains the largest number today. The large collection of flowers acquired by Queen Alexandra, indicative of her love for them, was second only to her passion for Fabergé's animal carvings of which she also owned an unrivalled collection. The flowers, like the animals, were mainly kept at Sandringham House, the estate acquired in 1862 by her consort, King Edward VII, then Prince of Wales.

Although Queen Alexandra enjoyed life at her London home, Marlborough House,[2] it was at Sandringham where she was happiest. Surrounded by her children, her horses and her dogs, she would drive around the estate each day in her pony cart.

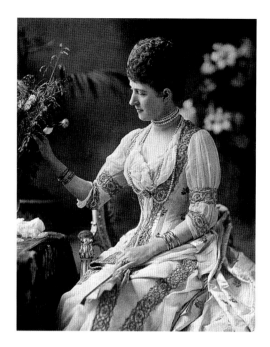

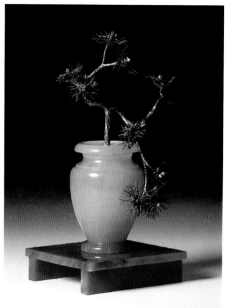

Viscount Knutsford describes accompanying her on such a drive in May 1900: "she
took pleasure in pointing out her plantations, her single trees, her cottages, . . . the rho-
dodendrons."[3] Edward VII rebuilt the house and had the gardens and grounds laid out
to his own designs. Disraeli, who was often a houseguest, describes the King's liking
for Sandringham: "He is really fond of this place, is making endless improvements in
his grounds . . . we had to go over 14 acres of *jardin potager*."[4]

With the King and Queen's joint interest in the gardens of their beloved
Sandringham, it is perhaps not surprising that several of Fabergé's floral works found
in the British Royal Collection were inspired by plants kept on the estate. The Pine
Tree (above) was commissioned by King Edward VII as part of his order placed
through the London branch in 1907.[5] It was modeled from life by Fabergé's sculptors,
who would have seen the collection of Japanese dwarf trees kept in the porch adjoining
the plant houses. Another of the hothouses was devoted to the growing of carnations

and a carnation made in Wigström's workshop (p. 80, far right), was also acquired by Queen Alexandra.

The Queen clearly loved flowers of all kinds, and in the grounds of Sandringham a new rose garden was created. There are three Fabergé roses in the Royal Collection, all probably acquired by Queen Alexandra, including a spray of wild roses in delicate pink enamel (p. 84). This may have been inspired by the roses at Sandringham; however, a similar flower exists in the India Early Minshall Collection at the Cleveland Museum of Art. A drawing from an album of designs from Henrik Wigström's workshop relates closely to both these Fabergé roses, but neither is marked.[6]

Queen Alexandra owned three Fabergé Pansies (p. 85) and her fondness for these flowers was demonstrated by the creation of a formal pansy garden adjacent to the House. A watercolor painting of this garden by Cyril Ward still hangs at Sandringham. Outside the Queen's Dairy, where butter was made from milk produced by the Sandringham herd and where picnic teas were often served to the Queen's guests, a Dutch garden was laid out. It featured clipped yew hedges and a tree planted by her young nephew the future Tsar Nicholas II on a visit to Norfolk in 1874.

Inside the house, Queen Alexandra's private rooms overflowed with potted plants and also informal bouquets in vases, often composed of wildflowers. Her brother, Prince Nicholas of Greece, marvelled that these were "mixed up with jewelled miracles of Fabergé's craftsmanship and swarming bibelots of every description."[7] The taste for rooms in which every surface was crowded with photograph frames, ornaments, mementoes and objets d'art of every imaginable kind was shared by her sister Tsarina Marie Feodorovna, who had arranged her private apartments in St. Petersburg in a similar manner.

For the formal drawing rooms and the dining room at Sandringham, Queen Alexandra preferred more grandiose floral decorations. Viscount Knutsford describes the table at dinner in October 1907: "the Queen likes high decorations, so they went half way up to the ceiling in great arches with bunches of grapes hanging down."[8] Queen Alexandra often received flowers for her birthday (December 1), which was almost always spent at Sandringham. In 1909 the gifts included "three very large

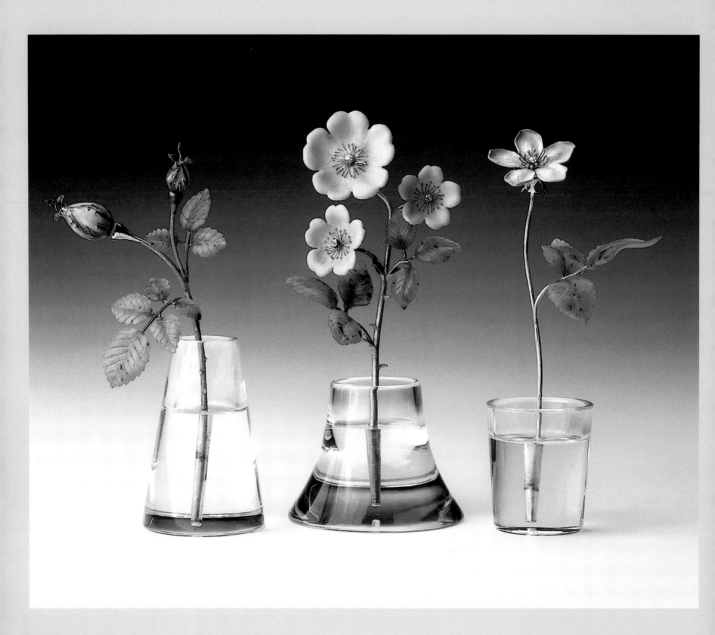

OPPOSITE

Wild Roses. Fabergé, c. 1900. Gold, enamel, nephrite, brilliant diamonds. Height 5¾ in. Unmarked. The Royal Collection, Her Majesty Queen Elizabeth II

From the original collection of Queen Alexandra, this is one of the early flower studies made before the Fabergé firm began to produce flowers carved from mineral stones in 1908.

RIGHT

Three Pansies. Fabergé, two at left c. 1900; on the right Workshop of Henrik Wigström, c. 1903–1908; two at left: gold, enamel, nephrite, brilliant diamond, rock crystal; one at right gold, enamel, nephrite, rose diamond, rock crystal; heights 4 in.; 4³⁄₁₆ in.; 4 in. Two at left unmarked; one at right marked *H.W.* for Wigström; *72;* Russian gold mark; *Faberge* in Cyrillic letters. The Royal Collection, Her Majesty Queen Elizabeth II

The Fabergé workshops produced a number of pansies. Queen Alexandra had three in her collection, which are seen here.

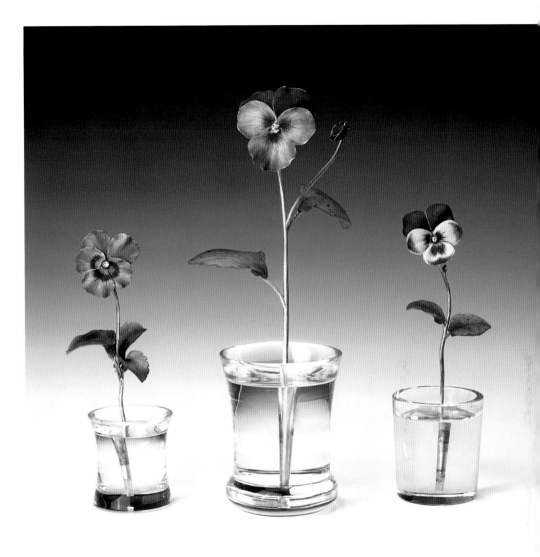

boxes of marvellous orchids from Colonel Holford" and "flowers from the Riviera."[9]

Nor was it uncommon in St. Petersburg for the Empress Marie Feodorovna to receive fresh flowers packed in ice from the south of France; she also made extensive purchases from local greenhouses. Both sisters, it would seem, had a profound need to be surrounded by nature. In St. Petersburg, one could attribute this longing to the seemingly never-ending Baltic winter; at Sandringham in the east of England, to the cold and often wet shooting season when King Edward and Queen Alexandra were in residence. Fabergé flowers provided both sisters with a constant welcome reminder of milder weather. As well, the fanciful nature of Fabergé's work must surely have brightened up the dark days of the northern climate.

To appeal specifically to Queen Alexandra, Carl Fabergé crafted many of the flowers reminiscent of those that abounded in her own garden at Sandringham: the quintessential English hedgerow with wild roses, catkins, holly and rowan berries (pp. 84, 87, and 88). For his most avid client, the master jeweller also created hardstone flowers of plants commonly found in Alexandra's childhood gardens of Denmark; to wit, the lingonberry (p. 90, left). This last might well have been a sisterly gift from St. Petersburg.

The appeal of Carl Fabergé's botanical work for his two most important royal clients was of course more than merely a response to their respective nostalgia. The delicacy of Fabergé's modeling and attention to detail—from the patina of the enamel on the pansies (p. 85), for example, to the jewelled and enamelled bee on a buttercup (p. 91)—has made them works of art today.

The Wild Cherries (p. 90, right) incorporate some of Fabergé's most successful techniques: enameling, gem setting, and hardstone carving. For each aspect of the flower creation, Carl Fabergé employed a different workmaster. And each flower required artists and craftsmen gifted in a variety of disciplines. A single flower was a long and painstaking creation.

The long tradition of hardstone carving in Russia was a major source of inspiration in the creation of Fabergé flowers and animals. The Russian Empress is known to have acquired grapes and other fruits executed in semi-precious stones from the Ekaterinburg and Peterhof stone-carving factories.

Catkin. Fabergé, Workshop
of Feodor Afanassiev,
c. 1900. Two-color gold,
nephrite, rock crystal.
Height 5³⁄₁₆ in. Marks: *F.A.*
in Cyrillic for Feodor
Afanassiev; gold mark of *56.*
The Royal Collection, Her
Majesty Queen Elizabeth II

The five catkin blooms of
yellow spun gold hang from
a red gold stem with
nephrite leaves. The stem,
characteristic of an autumn
find in the forest, is placed
iṅ a rock crystal vase with
carved water. This catkin,
unique in the work of
Fabergé, is from the collec-
tion of Queen Alexandra.

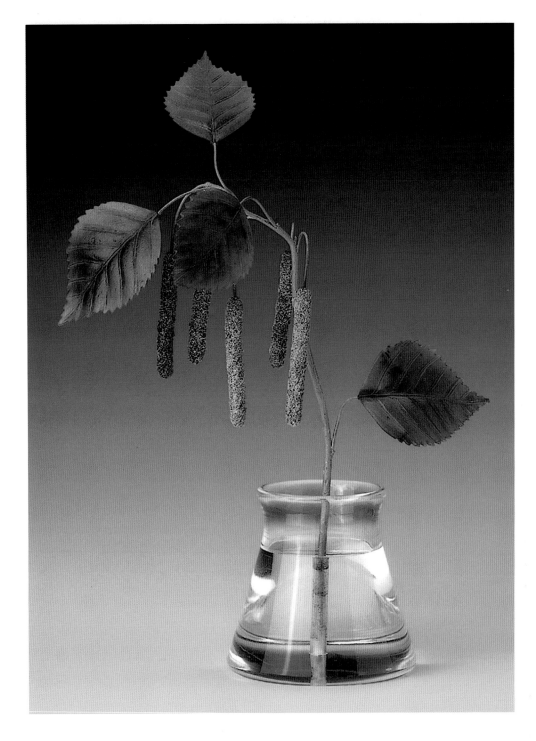

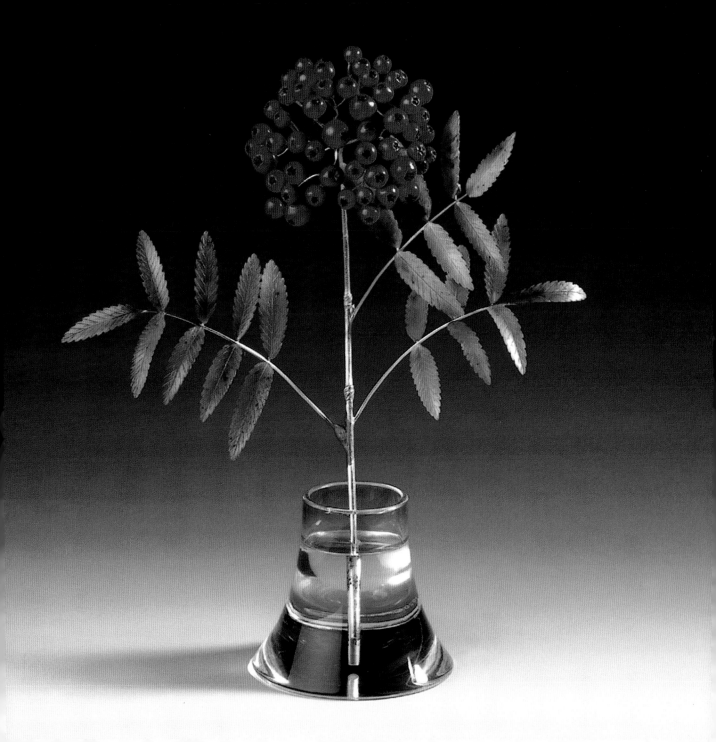

Carl Fabergé insisted that his work be as realistic as possible. His lapidaries improved on early models by selecting the correct stone with just the right hue to imitate the natural coloring of a flower or berry. So successful was the carving and so painstaking their work that even the variations in the ripeness of Fabergé fruit could be described in stone. This is especially apparent in some of the plants in Queen Alexandra's collection, such as the Raspberry (p. 93), which incorporates berries with differing shades of rhodonite and nephrite, some highly polished, others left matte. In other examples, such as the Rowan (opposite), the berries have reached the peak of their ripeness and some have begun to decay.

Queen Alexandra evidently appreciated the artistic merit of these objects, particularly the quality of the carving. During a visit to St. Petersburg in 1894, she visited a local stone cutting factory.[10] Yet despite the quality of Fabergé's work, Queen Alexandra, like most of her contemporaries, regarded her Fabergé flowers primarily as decorative objects, not as great works of art. She was, however, aware of their great fragility, and throughout her lifetime she kept her Fabergé collection in two display cabinets in the drawing room at Sandringham. When new pieces were acquired, she would re-arrange her collection. With the advent of electricity in Sandringham, the cabinets would be lit up during evening entertainments so that her guests could admire the charm of her displays.

Although Queen Alexandra made frequent visits to Fabergé's London shop, most of her purchases from this branch were intended to be gifts. She made only one purchase of a flower study for herself. According to the sales ledgers, on June 27, 1909, Alexandra bought a raspberry bush. Since there are two raspberry plants in the Royal Collection (p. 93) and both, like most Fabergé studies, are unmarked, the one she bought for herself cannot be identified. Another raspberry study, the earliest flower to enter the collection, was given to Queen Victoria in 1894 by her Lord Chamberlain (according to a notation in Queen Mary's inventory of Fabergé, dated 1949).[11]

In turn, most of Queen Alexandra's Fabergé flowers, like the rest of her collection, had been presented to her as gifts. Some came from members of her own family, such as the Pine Tree purchased in 1908 by the Prince of Wales, later King George V (p. 82).

Others were given to her by friends, notably the Japonica and the Chrysanthemum (pp. 80, 101), which were purchased by Stanislas Poklewski-Koziell, a councilor at the Russian Embassy and a good friend of Edward VII. Poklewski-Koziell was a regular customer at Fabergé's London branch, the manager of which described him "as the most prolific present giver the world has ever seen."[12] The Queen also received (in 1908) a holly sprig as a gift from the Honorable Mrs. George Keppel, King Edward VII's favorite mistress.

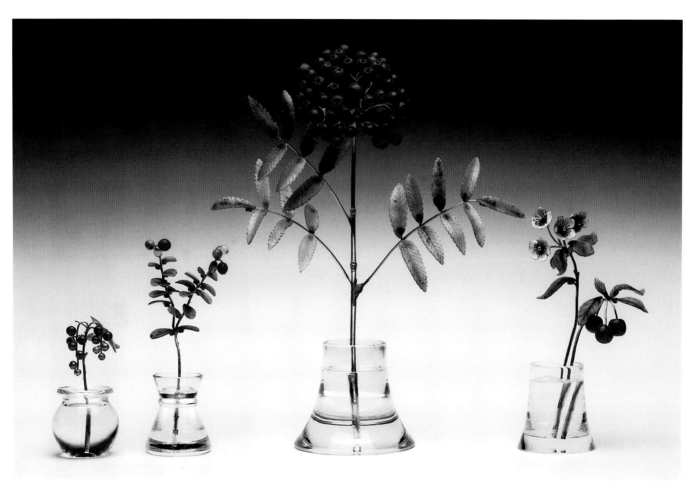

RIGHT

Bumble Bee on a Buttercup
(detail of the piece shown
on p. 98). The diamond-set
bee with ruby eyes is
perched on a buttercup,
about to take some nectar.

OPPOSITE

Lingonberries, Red
Currants, Rowan Tree, and
Wild Cherries. Fabergé, c.
1900. Lingonberries: gold,
cornelian, chalcedony,
nephrite, rock crystal; Red
Currants: gold, red enamel,
nephrite, rock crystal;
Rowan Tree: gold, purpurine,
nephrite, rock crystal; Wild
Cherries: gold, purpurine,
enamel, brilliant diamonds,
nephrite, rock crystal.
Heights 4 3/16 in., 5 in., 8 7/8 in.
and 5 5/16 in. respectively.
All unmarked. The Royal
Collection, Her Majesty
Queen Elizabeth II

All four pieces are from
the collection of Queen
Alexandra.

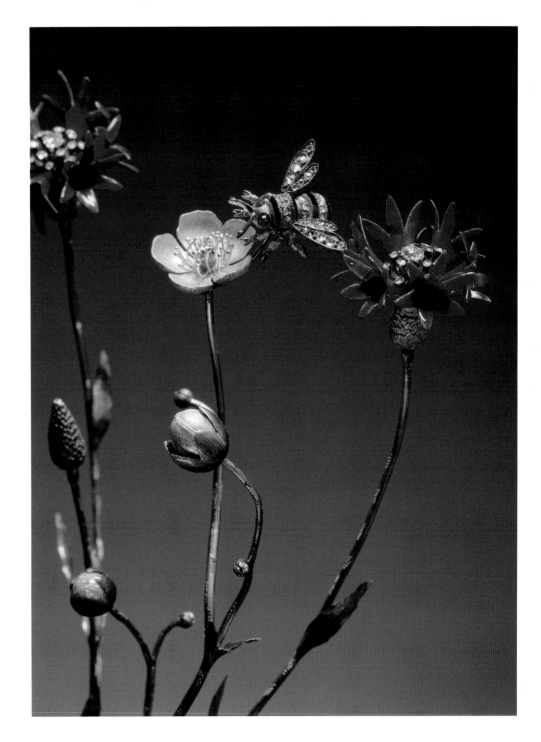

The Queen's birthday was the favorite occasion for presenting Alexandra with a gift from Fabergé—either from St. Petersburg or purchased from the London branch. Carl Fabergé personally sought ideas to create suitable gifts. "For nine months of every year Fabergé's principal establishment in St. Petersburg buzzed with the conception and preparation of the things for her birthday table."[13] Describing the contents of her birthday table at Sandringham in 1909, Viscount Knutsford recalls "there is a man in Dover Street who makes them, and a man in Paris makes flowers of the same stone."[14] The Dover Street reference was to Fabergé's London branch; the man in Paris is undoubtedly Cartier who, inspired by Fabergé's success at the famous 1900 Paris Exposition, began to make his own flowers in gold, enamel and semi-precious stones. According to materials supplier Aristide Fourrier, Cartier's early flower studies were entirely inspired by Fabergé, although the firm later developed a more distinctive style. Although there are no Cartier flowers in Alexandra's collection, Queen Mary acquired a lilac flower in 1924, which is attributed to him.[15]

The Christmas holidays, always spent at Sandringham, were another opportunity both to give and to receive Fabergé gifts. Each year the King and Queen would lay out presents on tables in the ballroom, and after presenting gifts to their staff, they exchanged their own gifts. Sir Frederick Ponsonby noted, "the King and Queen, of course, received wonderful things from their relations in Europe, the Emperor of Russia sending particularly lovely things by special messenger."[16]

To date, it has not proved possible to identify which of those flowers Queen Alexandra received for her birthday and which for Christmas, nor precisely who most of the donors were. Undoubtedly several gifts were received from her sister, Marie Feodorovna, who also had formed her own collection of flowers. It is quite possible that the sisters exchanged Fabergé flower gifts during the annual family holidays with their parents in Denmark. However, the only evidence is found in the Imperial ledgers, which reveal the Empress' increased expenditures with the Fabergé firm prior to her trips to Copenhagen.

In spite of the birthday and Christmas tables laden with Fabergé, Queen Alexandra in fact had rather modest taste and restricted herself to Fabergé's less expensive pieces.

Raspberries and Wild Strawberry. Fabergé, c. 1900; Raspberries: gold, rhodonite, nephrite, rock crystal; Wild Strawberry: gold, enamel, pearl, nephrite, rock crystal. Heights 3 9/16 in., 6 1/4 in., and 4 1/2 in. respectively; unmarked. The Royal Collection, Her Majesty Queen Elizabeth II

The Fabergé workshops produced a number of raspberry studies. These two are shown with a study of early wild strawberries, not yet ripe, enameled in varying shades of red and white on a gold stem. These are the tiny, sweet wild strawberries preferred by the Russians rather than the large cultivated berries best known in America. All three pieces are from the original collection of Queen Alexandra.

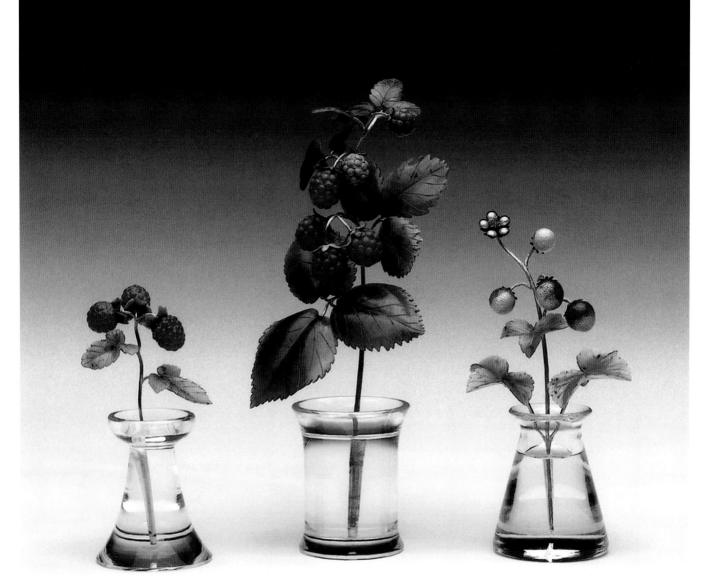

Gifts for the Queen, about which the manager of Fabergé's London branch was regularly consulted by her friends, were at Alexandra's own request to be kept strictly under £50. Most gifts presented to her adhered to this strict rule. However, it was often difficult for Fabergé to produce appealing objects under the set limit. Indeed, some of Fabergé's flowers, owing to their intricate production, were among the most expensive objects produced.[17] The Chrysanthemum was purchased in December 1908 for £117.

Queen Alexandra maintained her passion for Fabergé's work throughout her life. There were Fabergé works at Hvidøre, the villa outside Copenhagen, which she shared with her sister. Some of these were specially commissioned. Although the villa was relatively modest, an abundance of flowers were to be found there, including climbing roses on high trellises (opposite).

Through her enthusiasm for Fabergé, Queen Alexandra encouraged many in her circle to become clients. Some of her friends were also keen collectors of flowers, including the Marchioness of Ripon and Lady Sackville. Queen Alexandra's greatest influence was probably on her immediate family. Her second daughter, Princess Victoria (1868–1935), became a steadfast Fabergé client. Upon notice that a fresh shipment had come in from St. Petersburg, Victoria would accompany her mother to the London branch where they would spend an afternoon examining the newly arrived pieces. Princess Victoria's own collection included both animals and flowers, some of which were bequeathed to her by her mother. These included the Rowan Tree (p. 88) and the Lily of the Valley (p. 80, left).

Queen Alexandra's daughter-in-law, Queen Mary (1867–1953), grandmother of the present Queen Elizabeth, was also an avid collector of Fabergé and added two examples to the flower collection including the Bleeding Heart (p. 97). Together with King George V, she also purchased the Basket of Flowers Egg in 1933. One of three Imperial Easter Eggs in the Royal Collection, the Basket of Flowers contains a remarkably delicate arrangement of wild flowers in shades of pastel-colored enamel (p. 43). Tsar Nicholas II originally presented it to Tsarina Alexandra Feodorovna for Easter 1901. The Egg's profusion of flowers appealed to both royal houses.

Final additions to the collection were made by Queen Elizabeth (1900–2002), who purchased the studies of Cornflowers and Oats in 1944 and of Cornflowers and Buttercups in 1947 (p. 99). These were the last additions made to the group of Fabergé flower studies, which represent three generations of royal collecting.

NOTES

1. H.C. Bainbridge (manager of Fabergé's London branch), *Twice Seven*, London, 1933, 182; H.C. Bainbridge, "Fabergé Flowers Naturalistic," *The New York Sun*, December 17, 1938.

2. Marlborough House was the London home of the Prince and Princess of Wales (later King Edward VII and Queen Alexandra) until the King's accession in 1901.

3. Sydney Holland Viscount Knutsford, *In Black and White*, London, 1926, 187–88.

4. Helen Cathcart, *Sandringham: The Story of a Royal Home*, London, 1964, 105.

5. The order was for portrait models of the animals found on the estate, and Fabergé sent sculptors from St. Petersburg, who were resident for several months. See C. de Guitaut, *Fabergé in the Royal Collection*, London, 2003, 21–24.

6. C. de Guitaut, 104.

7. Helen Cathcart, 148

8. Sydney Holland Viscount Knutsford, 231.

9. Sydney Holland Viscount Knutsford, 239.

10. During her visit to St. Petersburg in 1894 to attend the marriage of Grand Duke Alexander and Grand Duchess Xenia. RA VIC/QAD/1894 14 August.

11. RA GV/CC 55/242.

12. H.C. Bainbridge, *Peter Carl Fabergé. His Life and Work 1846–1920*, London, 1949, 83.

13. H. C. Bainbridge, *Twice Seven*, 182.

14. Sydney Holland Viscount Knutsford, 238.

15. C. de Guitaut, 247–49.

16. Sir Frederick Ponsonby, *Recollection of Three Reigns*, London, 1951, 153.

17. G. von Hapsburg and M. Lopato, eds., *Fabergé Imperial Jeweller*, Amilcare Pizzi/The Fabergé Arts Foundation, a Fabergé Arts Foundation exhibition catalogue, 1993, 458.

Bleeding Heart. Fabergé, c. 1900. Gold, rhodonite, quartzite, nephrite, rock crystal. Height 7½ in. Unmarked. The Royal Collection, Her Majesty Queen Elizabeth II

Queen Mary purchased this flower in London in 1934 when many Fabergé treasures from confiscated Russian collections were being sold abroad.

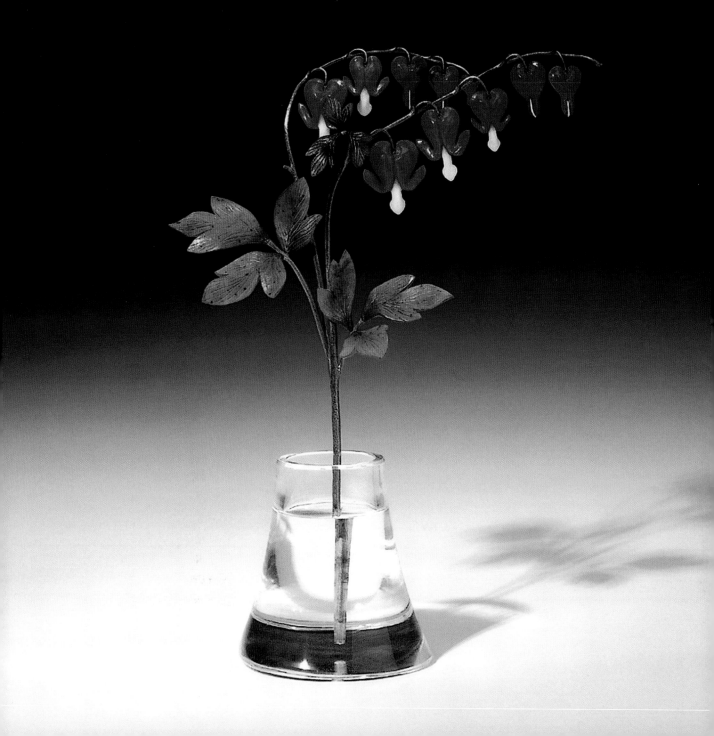

Cornflowers and Butter-
cups. Fabergé, c. 1900.
Gold, enamel, rose dia-
monds, rubies, rock crystal.
Height 8¾ in. Unmarked.
The Royal Collection, Her
Majesty Queen Elizabeth II

This charming study of
enameled wild flowers—
deep blue cornflowers and
bright yellow buttercups—
is actually a scene from
nature in the summer. A
diamond-set bumblebee
with ruby eyes, perched on
a buttercup, is about to
take some nectar that will
be used to produce honey.
Rose diamonds form the
centers of three buttercups
and the two cornflowers on
gold stems with gold leaves
in a rock crystal vase filled
with carved water. Three
yellow enameled buttercup
buds, some about to open,
complete the picture.

Bought by Queen Elizabeth
(later the Queen Mother)
from Wartski in 1947, this
flower study might have
come from one of the
Russian Imperial collections.

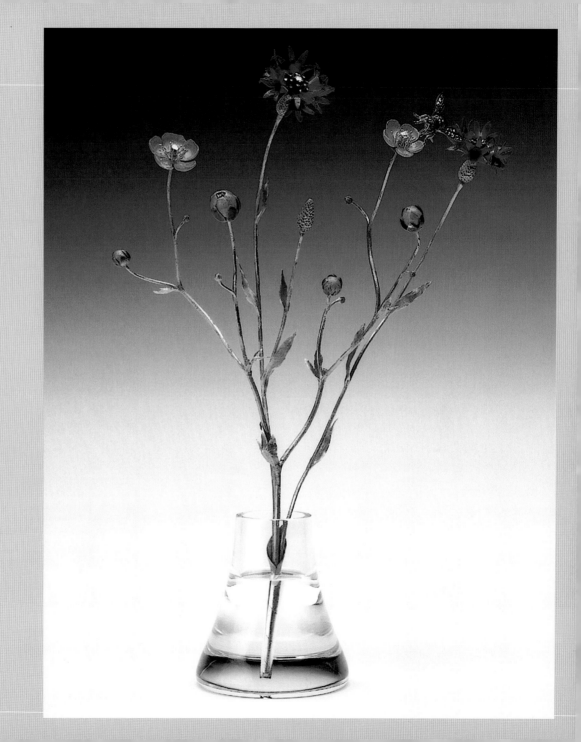

Fabergé's London Branch and the London Ledgers

 Tatiana Fabergé

London, the capital of the British Empire with its Royal Court, was a very logical choice for opening a branch outside Russia. Fabergé had visited England during his Grand Tour, and when he became the head of the family business in 1870 he never forgot what he had admired during his visit to London.

After reuniting all his workshops in 1900 in one prestigious building at 24 Bolshaya Morskaia Street and opening another branch of his house in Moscow together with a British citizen from South Africa, Allan Bowe, Carl Fabergé—a very talented artist and at the same time a very progressive businessman—decided to expand his firm.

Tsar Alexander III's widow, Marie Feodorovna, was the sister of H. M. the Queen of England, Alexandra. King Edward VII and his wife loved to receive beautiful presents by Fabergé, and of course all their entourage were delighted to also receive such gifts.

In 1903, Carl Fabergé decided to take a chance and sent Arthur Bowe, Allan Bowe's brother, to London to start doing business from the Berners Hotel. This developed successfully, and the firm had to move to larger premises in Portman House, Grosvenor Square, one year later.

During the Russo-Japanese war of 1904–05 the situation in Russia became very tense. There were very poor harvests, and in 1905, the First Revolution created great difficulties for Fabergé because of strikes and turmoil at industrial factories in St. Petersburg and Moscow.

In 1906, Carl Fabergé severed his partnership with Allan Bowe in Moscow and decided to continue his activities at 48 Dover Street in London. His new store was

placed under the management of his son Nicholas, with the help of H.C. Bainbridge. The store was later moved to 173 New Bond Street. This business move was very successful, as can be seen from the London ledgers, and the new location attracted a very cosmopolitan clientele. It also enabled Carl Fabergé to establish, directly from London, business connections in France, Italy, Egypt, Abyssinia, Siam, India, China, and Japan.

In fact, such an operation was very difficult to organize because of the distance from St. Petersburg, as well as the political situation. After 1906, things began to settle down. Then, in 1910, Fabergé was confronted with the problem of the demand by the Worshipful Company of Goldsmiths of England that all silver and gold objects be hallmarked by them. This was obviously impossible for enameled objects, and half-finished articles therefore were first sent to England to be stamped, then sent back to St. Petersburg to be enameled and finished, before being finally returned to London. The cost of the objects thus increased significantly.

When Fabergé's London branch closed after the Russian Revolution of 1917, the sales ledgers, which had been maintained by Nicholas Fabergé, were passed on to his brother, Eugene. I, in turn, inherited them from my father, a nephew of Eugene Fabergé, who had received them from him.

Entry from the London ledgers noting the Chrysanthemum bought by Stanislas Poklewski-Koziell, a councilor at the Russian embassy, as a gift for Queen Alexandra (see pp. 81, 90).

Entry from the London ledgers noting the Pine Tree bought by the Prince of Wales and given to his mother, Queen Alexandra

Date.	Customer's Name.	Description of Goods.	Stock Number.	Details. £	Details. s.	Details. d.	Total. £	Total. s.	Total. d.	S. L. Folio.	Rbls.	Cop.	Cost Price.
	P. Poklewski, Esq.	Chrysanthemum, pink and yelow enl: neph.leaves, gold	17641	117	.	.							516

Dec. 14th '08 to Jany. 13 '09.

Date.	Customer's Name.	Description of Goods.	Stock Number.	Details. £	Details. s.	Details. d.	Total. £	Total. s.	Total. d.	S. L. Folio.	Rbls.	Cop.	Cost Price.
1908 Dec. 14	Prince of Wales	Sp. Pine, red & green gold, ortz. Pot of Jadeite	14180				52	10	.	165			328

101

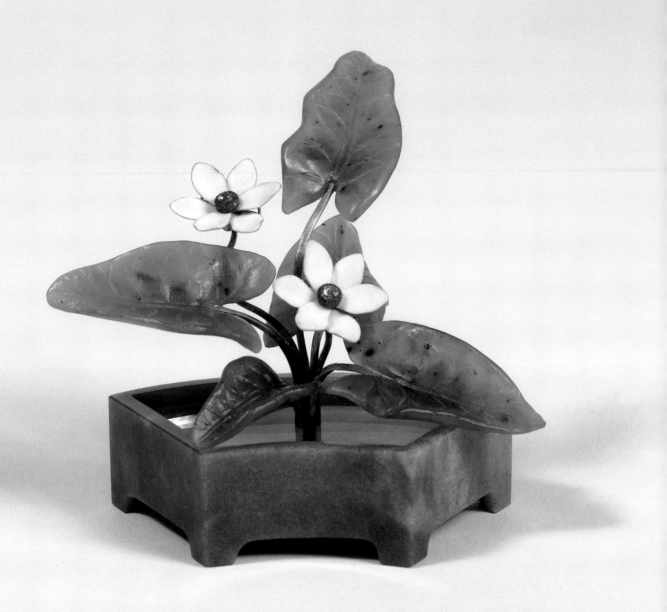

In Search of Fabergé Flowers in Russia

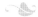 Valentin V. Skurlov

Note: The following material comes from the St. Petersburg researcher, Valentin V. Skurlov, who has discovered much new information in Russian archives as a Sherlock Holmes of Fabergé. The lists of Fabergé flowers bought by various members of the Imperial family; excerpts from the memoir of Alexander A. Fabergé; and aspects of flower culture in St. Petersburg before 1917 are all published here for the first time in English from material translated by Dudley Hagen.

Very few archival documents on Fabergé's flower compositions have come down to us. In general, there cannot have been many "flowers from Fabergé." About forty floral compositions were sold through the London branch of Fabergé (see pp. 100–01). In Russia, the most information is known about the collection of Grand Duchess Marie Pavlovna, who had thirty-four Fabergé flowers. After the revolution in October 1917, all of the flowers from her palace seem to have come into the possession of Arkady K. Rudanovsky, a well-known pre-revolutionary antiquarian and former cavalry captain. In May of 1919, Rudanovsky and Agathon K. Fabergé were arrested on charges of speculating in antiquities. Agathon Fabergé spent sixteen months in prison. Rudanovsky's fate is unknown, but the archive of the Hermitage has a list of articles confiscated from him, which includes thirty-four floral compositions. The well-known Narcissus now in the Hermitage collection is described as coming from Rudanovsky, as well as the Red Currants and the Sweet Pea. But where are the other thirty-one flowers?

Forget-Me-Not. Fabergé.
Gold, turquoise, diamonds,
nephrite, eosite, rock crystal.
Height 4⅝ in. Unmarked.
Private Collection

In 1920, four Fabergé flowers were taken from the house of I.I. Vorontsov-Dashkov, a former minister of the Imperial Court, at 9 Galernaya Street. These were Lilies of the Valley of pearls and rose-cut diamonds in a silver cachepot, a rhodonite Raspberry in a rock crystal vase, an enameled Violet in a rock crystal vase and a composition of dark blue and white flowers in a vase.

In 1921, ten Fabergé floral compositions in rock crystal vases were removed from the safe in the bank where Prima Ballerina Mathilde Kschessinska's things were kept. She recorded in her memoirs that on February 22, 1917, one week before the revolution began, she had a dinner party: "I had a mass of little Fabergé things: there was a large collection of wonderful artificial flowers made of precious stones. Among them was a golden fir tree with little diamonds on its branches. A few days later everything was stolen."[1] Oleg Agafonovich Fabergé remembered two golden fir trees with a thousand diamonds on the needles that were in their apartment in Petrograd.[2] They stood shielded under hemispheres of rock crystal. Where those trees are today, no one knows.

In 1922, four Fabergé flowers were recorded at the Armory Chamber of the Moscow Kremlin in the crate containing the Imperial Easter Eggs taken from the palaces in Petrograd. These were two Forget-Me-Nots of turquoise and rose-cut diamonds in rock crystal vases, a gold flower in a rock crystal vase, and one additional flower with a diamond in a rock crystal stand. That same year, the Kremlin listed a "cactus" among articles released for sale at auction.

The enameled Pansy in a rock crystal vase (pp. 52–53) that opens to reveal five miniature portraits, remains in the collection of the Armoury Chamber today. This was a tenth wedding anniversary gift to his spouse, for which Nicholas II paid 1,075 roubles on November 11, 1904.

Many authors, in speaking of flowers, cite Carl Fabergé's famous interview with a correspondent from the journal *Stolitsa y Usadba (Town and Country)*. In that interview, the correspondent claims that the flowers cost 2,000 roubles. This is clearly an exaggeration of great magnitude. Most of the flowers that pass through the account books of Empress Marie Feodorovna, Emperor Nicholas II and Empress Alexandra Feodorovna, as well as those of the London branch, show that the price of such flowers

was between 250 and 350 roubles. Not long ago, reviewing the account books of Grand Duke Alexander Mikhailovich, another flower was discovered: "4 January 1899, Fuchsias in a vase, 350 roubles." Occasionally as much as 500 roubles were paid. Of course, 500 roubles was a lot of money. One rouble was the equivalent of $8.50 in today's currency, so 500 roubles was $4,250. In the early 1990s, Christie's offered several hardstone flowers for $1,500–2,500.

In that same interview, Fabergé pointed out another detail about the flowers: they make suitable gifts when "it is awkward to give expensive jewels." "Something of this kind will be suitable." In these compositions, it is not the price of the materials, but the aesthetic value and quality of the craftsmanship that is most important. Although many of the vases of the flowers were made of rock crystal, there were also pots made of semi-precious stones (p. 104). In the collection of Grand Duchess Marie Pavlovna were a Tiffany vase, a nephrite vase, and four jasper vases, one of which is mounted on a little jadeite bench. In the photographs of flowers from the firm's album, preserved in the mineralogical museum named for Academician A.E. Fersman, almost half of the vases are made of material other than rock crystal.

Nothing is known however, about the flowers that such famous clients as Nobel, Yeliseev, Koenig, or Kelch bought from Fabergé. In the milieu of the aristocracy, to be a discerning judge of flowers was seen as a natural and necessary sign of education. Performing artists too, had a great appreciation and understanding of flowers, beginning with the ballerinas. There are many words devoted to flowers in the memoirs of Mathilde Kschessinska, Anna Pavlova, Karsavina, and others. Kschessinska records how "at Easter Grand Duke Andrei . . . would always give me an enormous egg-shaped bouquet of lilies of the valley, with a precious stone, also in the shape of an egg, from Fabergé."[3] After a farewell performance at the Mariinsky Theatre on February 4, 1904, she "received an enormous amount of flowers and a great many valuable gifts, including a gold laurel wreath, made to measure, each leaf engraved with the name of the ballets I had danced: a real floral tribute."[4] Did it come from Fabergé? This is not recorded. When Marie Gorshkova (wife of the sculptor Boris Froedman-Clousel) visited Anna Pavlova's apartment, she was struck by the abundance of live flowers that filled every room.

There were one hundred florists in St. Petersburg in 1912, belonging to eighty-four
owners. Foreigners owned forty-five of these stores, following the tradition of specialists
from Western Europe since the time of Peter the First. Several stores specialized in flowers
imported on the Petersburg-Paris-Nice express train.

Herman F. Eilers (1837–1917),[5] who owned the largest number of stores—five—was also
one of the most prominent, receiving the title of Purveyor to the Imperial Court in 1895,
an honor rarely given to horticulturalists and florists. Eilers won top prizes for his azaleas,
roses, and lilacs, as well as for bridal bouquets and decorations for special events. Eilers's
office and main store was located at 19 Bolshaya Morskaya, a few doors down from Fabergé
at 24 Bolshaya Morskaya. Is it possible that some live models for the Fabergé flowers came
from Eilers's store, "Flora"?

Inspiration for the berries and wild flowers made in the Fabergé workshops may have
originated at Carl Fabergé's own dacha[6] in Levashovo outside of St. Petersburg. Wild
strawberry,[7] raspberry, currant, fuschia and lily of the valley are among the many flowers

and berries that grew at the dacha and in the area around Levashovo, as described in the charming memoir of Alexander A. Fabergé.[8] Grandson of Carl Fabergé, Alexander spent several childhood summers at Levashovo from 1913 to 1916 and recalled how "our cook Karolina was making jam from wild strawberries in a copper pot. Where did the berries come from? Home grown. Raspberries grew at the bottom of the garden, between the avenues and the ditch. There were several rows of white raspberries in that avenue as well. . . . The walls of Opapa's (Carl Fabergé–V.S.) study were hung with roots and branches that had grown back onto themselves. Once I found myself a twisted root, cut it off, and gave it to Opapa as a gift. I cut it with my own sharp little knife. Opapa's favorite flower was in the forest, Asperula odorator." This is a typical flower in the Finnish suburbs of St. Petersburg. It is an ordinary wildflower, nothing noble.[9]

Between 1896 and 1907, before the Ekaterinburg craftsmen Peter Kremlev and Derbyshev came to St. Petersburg in 1908, the firm made only six flowers for the Empresses Marie Feodorovna and Alexandra Feodorovna, Nicholas II, and Grand Duke Mikhail Alexandrovich. The number increased after 1908. Between 1908 and 1915, eight more flowers were made for these same clients, and restoration work was done on two flowers, as shown by the list of flowers purchased by members of the Imperial family:

FLOWERS PURCHASED BY MEMBERS OF THE IMPERIAL FAMILY

28 April 1897	Flower and three diamonds in a crystal glass, 135 roubles—His Majesty, the Emperor
4 December 1899	Lilies of the Valley in a rock crystal glass; 20 pearls, 84 "roses" (rose-cut diamonds) and nephrite leaves, 250 roubles—His Majesty, Emperor, in half shares with the Empress (125 roubles each)
30 December 1900	Forget-Me-Not, enameled, in a rock crystal glass with nephrite leaves, 225 roubles—Grand Duke Mikhail Alexandrovich

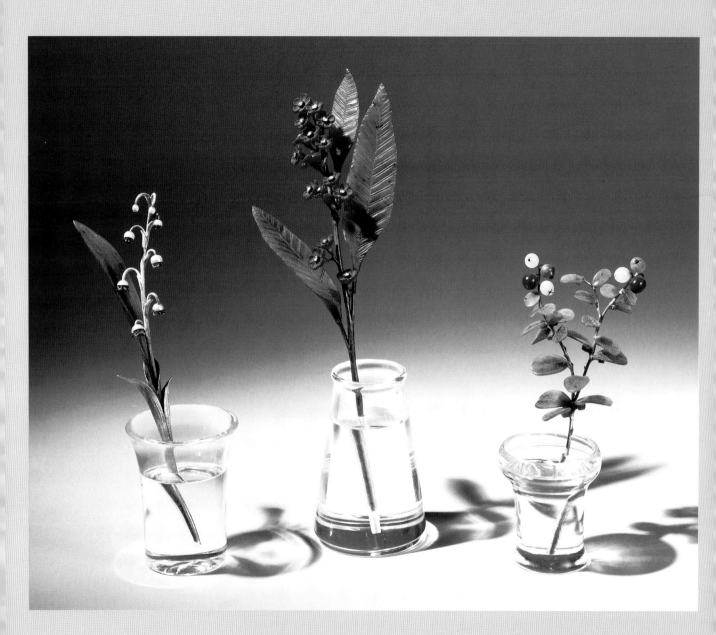

30 March 1906	Flower, 275 roubles—Empress Marie Feodorovna
25 May 1907	Flower, 335 roubles—Empress Marie Feodorovna (information found in her notebooks)
24 May 1908	Red Whortleberry flower, 175 roubles—Empress Marie Feodorovna
4 July 1908	Flower, 325 roubles—Empress Marie Feodorovna
12 January 1910	Flower, 425 roubles—His Majesty, the Emperor (in half shares with the Empress, 212 roubles, 50 kopecks each)
22 April 1911	Flower, 250 roubles—Empress Marie Feodorovna
22 March 1914	Lily of the Valley, 275 roubles—Empress Marie Feodorovna
5 February 1915	Repair of a nephrite leaf of a Narcissus, 3 roubles—Empress Alexandra Feodorovna
24 April 1915	Flower, 500 roubles—Empress Marie Feodorovna
11 July 1915	Repair of a small leaf belonging to a flower, 5 roubles—Grand Duchess Marie Pavlovna (information found in Fabergé's invoice)
7 November 1915	Repair of a small leaf belonging to a flower, 5 roubles—Empress Alexandra Feodorovna
14 November 1915	Primrose, 350 roubles—His Majesty, the Emperor (in half shares with the Empress, 175 roubles each)

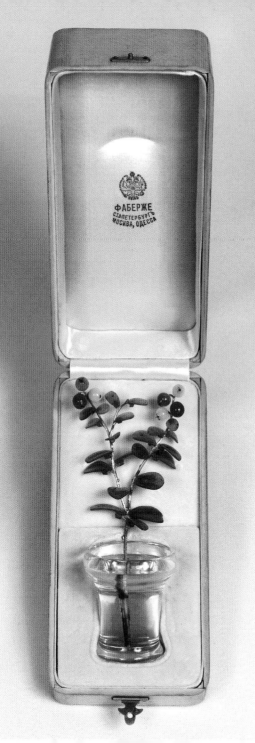

Mountain Cranberries, in its original fitted case. Courtesy of A La Vieille Russie

14 November 1915 Pansies, 225 roubles—His Majesty, the Emperor (in half shares with the Empress, 112 roubles, 50 kopecks each)

On October 30, 1917, five days after the October revolution, an inventory of thirty-four Fabergé flower studies from the palace of Grand Duchess Marie Pavlovna, widow of Grand Duke Vladimir Alexandrovich, was compiled and remains today in the Russian State Historical Archives (RGIA).

FABERGÉ FLOWERS OF GRAND DUCHESS MARIE PAVLOVNA

Cyclamen—nephrite stem, flower of white quartz with one diamond, in a vase of rock crystal.
Sweet Pea—nephrite stem, flower of white quartz, vase of rock crystal, furnished with a mirrored cap, silver gilt setting and pedestal of amaranth wood.
Lily of the Valley—nephrite leaves, gold stem, flower of pearls and "roses" (rose-cut diamonds) in a vase of rock crystal.
Dog Rose—nephrite leaves, gold stem, enameled flower with one diamond in a vase of rock crystal.
Whortleberry—gold stem, nephrite leaves, red berries of various stones in a vase of rock crystal.
Forget-me-not—gold stem, nephrite leaves, enameled flower with one diamond in a vase of rock crystal.
Wild Strawberry—gold stem, nephrite leaves, enameled berries, flower of pearls and "roses" in a vase of rock crystal.
Bilberry—gold stem, nephrite leaves, stone berries.
Forget-Me-Not—gold stem, nephrite leaves, flower of sapphires, diamonds and "roses" in a vase of rock crystal.
Wildflower—gold stem, yellow enameled flower with diamonds in a vase of rock crystal.
Wildflower—gold stem, yellow enameled flower with diamonds.

Cornflower—gold stem, enameled flowers with diamonds in a vase of rock crystal.

Lily—gold stem, enameled leaves and flower with "roses" in a vase of rock crystal.

Wildflower—gold stem, gold flowers with "roses" in a vase of jasper.

Chamomile—gold stem, nephrite leaves, enameled flowers with "roses" in a vase of rock crystal.

Forget-Me-Not—gold stem, nephrite leaves with two diamonds in a vase of rock crystal.

Wildflower—gold stem, enameled leaves and flowers in a vase of rock crystal.

Cornflower—enameled stems and flowers in a Tiffany vase.

Red Flower—enameled with "roses," gold stem and bud, nephrite leaves in a vase of rock crystal.

Wildflower—flowers enameled with "roses," nephrite leaves in a vase of rock crystal.

Flower—gold stem, flower enameled with diamonds, nephrite leaves in a vase of rock crystal.

Dog Rose—gold stem, nephrite leaves, flower of rose quartz with one chrysolite.

Whortleberry—gold stem, nephrite leaves, red berries of various stones in a vase of rock crystal.

Dandelion—of gold and "rose," gold stem, nephrite leaves in a vase of rock crystal.

Cactus—of nephrite, flowers of rhodonite with "roses" in a rhodonite vase on a stand of white onyx.

Cactus—nephrite with enameled flower, vase of white onyx, stand of jasper on a miniature bench of jadeite.

Wild Strawberry—gold stem, nephrite leaves, enameled berries, flowers of pearls in a vase of rock crystal.

Bleeding Heart—gold stem, flowers of rhodonite, nephrite leaves, stone berries.

Pansies—gold stem, nephrite leaves, flower of sapphires with one diamond in a vase of rock crystal.

Wildflower—gold stem, nephrite leaves, yellow enameled flower in a vase of rock crystal.

Hyacinth—of white quartz, nephrite leaves and stem, in a jasper pot.

Flower—of pink enamel with one diamond, enameled leaves, gold stem in a vase of jasper.

Forget-Me-Not—of turquoise with "roses," enameled leaves and stem in a vase of rock crystal.

Wildflower—enameled purple with two diamonds, gold stem, nephrite leaves in a vase of jasper.

[From *Antikvarnoe obozrenie No.3/2001, pp. 21 and 38*]

NOTES

1. M. Kschessinska, *Dancing in Petersburg*, London, 1960, 163.
2. In 1915, during World War I, the name of St. Petersburg was changed to Petrograd, a more Russian and less German name.
3. Kschessinska, 95.
4. Kschessinska, 98.
5. Eilers had eight children, one of whom married into a family from which descended a daughter who married one of Carl Fabergé's sons, Agathon. They are the grandparents of Tatiana F. Fabergé. ("Fabergé's London Branch and the London Ledgers," p. 100)
6. A dacha is a house out of town where city dwellers go for the summer or weekends to enjoy the fresh delights of fields and woods.
7. Russians vastly prefer the tiny, sweet wild strawberries known as *zemlyanika*.
8. Alexander A. Fabergé (1912–88), doctor of biology, Cambridge University, 1936, wrote *Levashovo—A Reminiscence* in 1966. It is preserved in the archive of Tatiana Fabergé.
9. I made a special trip to the botanical garden of the Academy of Sciences in Petersburg to learn about this wildflower.

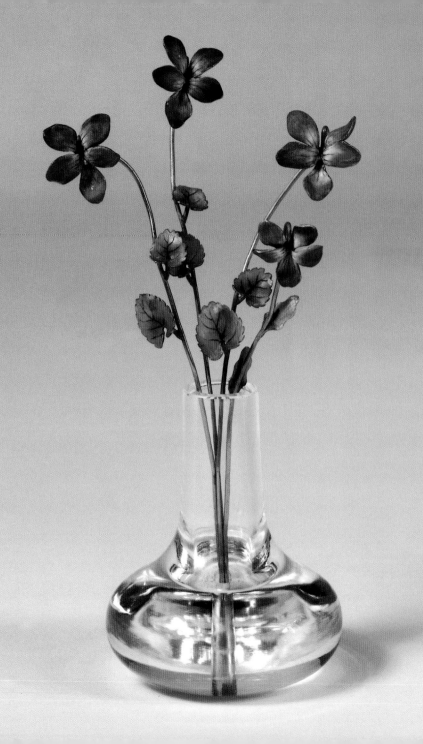

Fabergé's Flowers: Science in the Service of Art

 Mark A. Schaffer, A La Vieille Russie

Flowers began my education in the art of nature and the art of Carl Fabergé. As a child, I frequently had the opportunity to view (hands behind the back, of course) an indoor Fabergé botanical garden of intense and vital beauty, under the tutelage of my grandparents. These flowers brought life into the home, just as they had for Fabergé's original patrons during long, cold winters. What a challenge for this master jeweler to re-interpret the most exquisite of what nature offers! My own awe at these beautiful creations, both natural and jeweled, certainly helped trigger the pursuit of doctoral studies in plant biology at the University of California that preceded my returning to New York and joining the family firm, A La Vieille Russie, which specializes in antique jewelry and Fabergé pieces.

The representation of flowers and plants merges art and science, as much for Fabergé as for a Renaissance flower painter, or for the illustrator of a medieval herbal. Successful portrayal requires a sensitivity to the plant and its life cycle, how it might appear at various stages, with fruit or flowers or without, in vigorous health or wilted and brown. Fabergé's close attention to these details contributes to the natural appearance of his flowers, and those details imbue the flowers with their delicate feel or apparent sweet fragrance, in a way no other artist-jeweler has achieved. That the flow-

ers lean naturally in pots of rock crystal carved so as to appear filled with water enhances this effect.

Several examples illustrated herein exemplify Fabergé's botanical eye. The Violet's (p. 116) leaves display a subtle browning at the tips, evocatively rendered in enamel. With different shades of agate, the Mountain Cranberries (pp. 110, 112) are shown at varying stages of development. Fabergé could have portrayed the Dandelion (opposite) in bright yellow, but instead chose the challenging and evanescent seed-stage. The Daphne's (p. 121) delicate flowers are just barely open, rather than completely mature. And the smallest of the Buttercup's (pp. 91, 98) bright buds is slightly greener than its larger neighbors. Especially wonderful for me are the Strawberries, speckled with tiny achenes (pp. 122, 123): the backs are enameled slightly yellow, obviously because they're out of the sun!

Many of these can be found together in the wild, and they represent numerous plant families, from Rosaceae to Asteraceae to Liliaceae. This natural breadth not only adds to this group's verisimilitude, but also allows Fabergé's flowers to serve almost as an educational tool. I'm reminded a bit of Harvard University's Glass Flower collection, part of my own education. There, close to 850 models,[1] in colored glass and great botanical detail, show diverse plants at various stages and in three dimensions. Interestingly, these flowers, created by a father and son team, date to the last decade of the nineteenth century in Dresden, a city of so much inspiration for Fabergé, and ultimately a nexus for imitation of Fabergé's own work in the early twentieth century.

Fabergé is renowned for transforming enamel and hardstone, with a touch of gold and diamonds, into objets d'art. In the case of his flower studies, he successfully evokes the same emotional response as to flowers in a meadow or garden. Their beautiful and fragile construction conveys the beauty and fragility of nature. They combine man-made and natural beauty. In so doing, they combine two of my own passions, art and biology, and allow me the continued pleasure of their intersection.

NOTE

1. R.E. Schultes and W.A. Davis, *The Glass Flowers at Harvard*, Botanical Museum of Harvard University, Cambridge, Massachusetts, 1992.

A dandelion seed puff of asbestos fiber supported on diamond-tipped gold stamens is set on a gold stem with two carved nephrite leaves in a faceted rock crystal glass with carved water. Dandelions were among the most successful of the Fabergé flower studies, as Franz Birbaum, Fabergé designer, described in his memoir of the firm. Each one was made differently, as can be seen in several of the surviving examples.

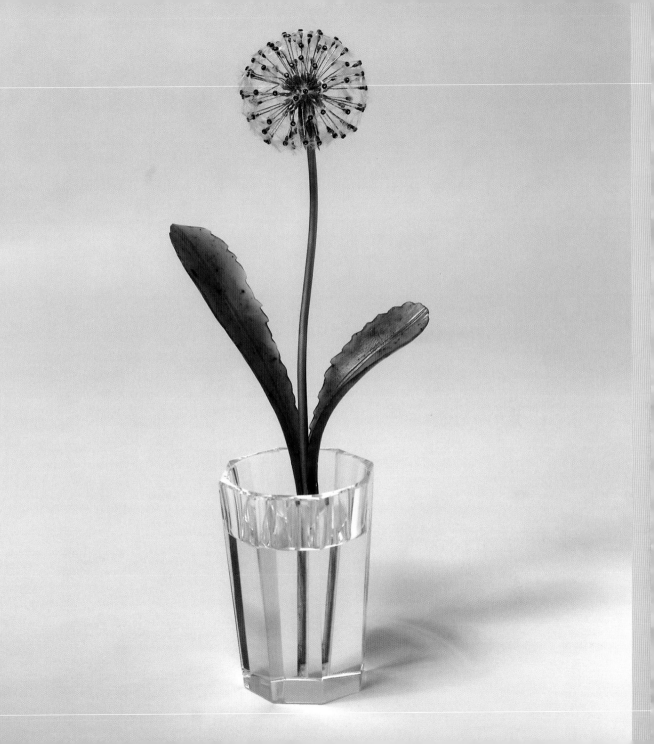

Daphne. Fabergé, c. 1900.
Gold, enamel, diamonds,
nephrite, rock crystal.
Height 4¼ in. Unmarked.
Courtesy of A La Vieille
Russie

A unique piece, this
summer flower displays
five globular petals realisti-
cally enameled white and
red with tiny, diamond-set
centers.

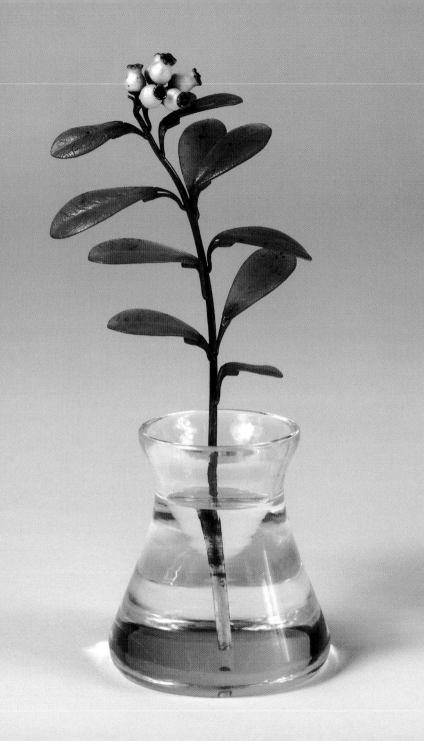

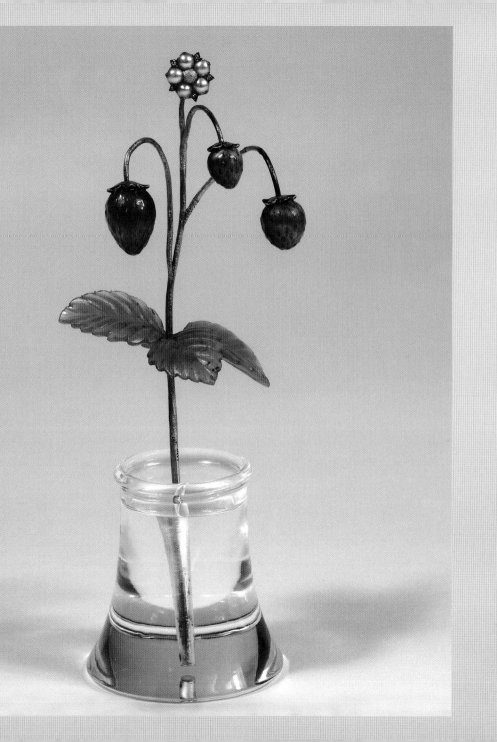

Three alpine Strawberries in translucent red enamel and a diamond-set flower with a yellow enamel center, are on a gold stem with three nephrite leaves. The stem stands in a rock crystal pot of carved water. Front view showing sun-ripened side of the berries. Height 4¾ in.

OPPOSITE
Back view of the alpine Strawberries that are enameled slightly yellow, not yet sun-ripened

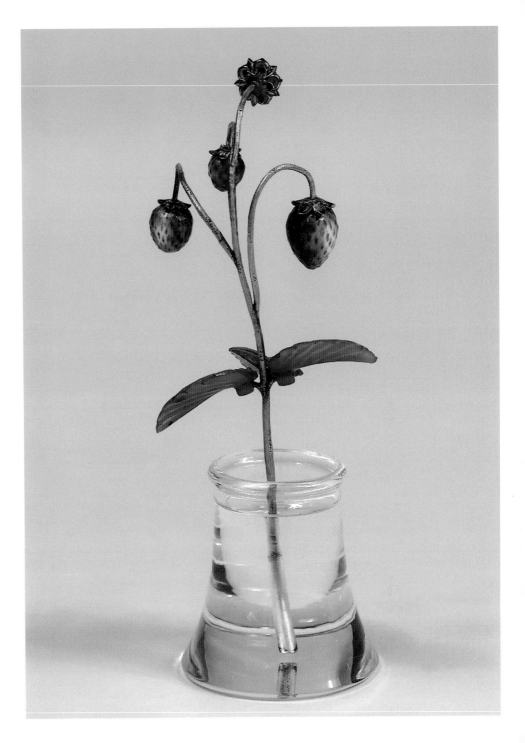

Index

Note: Figures in *italics* refer to illustrations.

A

A La Vieille Russie, *116*, *117*, 118
Alexander III, Emperor, 11, 34, 39, 72
Alexander Palace, 54
Alexandra, Queen, 34
 collection, *80*, 81–94, *82*, *84–85*, *87*, 88,
 90–91, *93*
 photographs of, *82*, 95
Alexandrovich, Grand Duke Alexis, 56
Alexandrovich, Grand Duke Mikhail, 108
Alexandrovich, Grand Duke Serge, 48
Alexandrovich, Grand Duke Vladimir, 22,
 24, 39, 113
Alexandrovich, Tsarevich Nicholas, 48
Alexandrovna, Grand Duchess Olga, 48
Alexei, Tsarevich, 17–18, *18*
Alexis, Grand Duchess, 51
 portrait of, 51, *52*, *53*, *105*
Alix of Hesse and by Rhine, Princess, 48,
 51
Anastasia, Grand Duchess, 48, 51
 perfume, 56
 portrait of, 51, *52*, *53*, *105*
animals, 20
 Queen Alexandra's, 81, 86, 94
apple blossoms, 70
aquilegia, *18*, 18–19
Armory Chamber collection, 105
Art Nouveau style, 29, 33–34

B

Bainbridge, H. C., 101
Baletta, Elizabeth, 4, 56
ballerinas, 106. *See also specific individuals*
bark, 29, *30*
bee, on buttercup, 86, *91*, 98, *99*, 118
bench, jadeite, 106
Birbaum, Franz P.
 on Chinese influences, 19, 36, 39
 on dandelions, 33–34, 71, 118
 on Paris exposition, 41
bleeding heart, *27*, 36, 44
 Queen Mary's, 94, 96, *97*
 rhodonite for, 70
blueberry branch, 39, *40*, 41
bonsai, 27
 pine tree, 29, 30, *30–31*
Bowe, Allan, 100
Bowe, Arthur, 100
bowenite vases, 29, 30, *30–31*, *82*
British Royal Collection, 11, 20, 82
brooch, rose, *6*, 7
Buckingham Palace, 20
Bulla (photographer), 41
buttercups, 27, 36, *38*, 72
 bee on, 86, *91*, 98, *99*, 118
 cornflowers and, 96, 98, *99*
Buxhoeveden, Baroness Sophie, 51, 54

C

cactus, *64*, 66, 105
carnations, 80, *80*, 82–83
Cartier, Louis-François, 92
cases, pyramid-shaped, 41–43, *42*, 44, *45*
Catherine the Great, 34, 47

catkin blooms, 86–87, *87*
Chamberlain, Lord, 89
cherries
 blossoms, *64*, 66, 70
 lily of the valley and primula, 56, *57*
 wild, 29, 86, *90*, 91
chestnut leaf tray, 13, *13*
Chinese influences, 19, 36, 39
Christie's auction house, 106
chrysanthemums, 27, 29, 80
 Queen Alexandra's, 80, 80–81, 94
Compact, 28
copper, 29
 alloyed with gold, 71
cornflowers, 56, 72
 buttercups and, 96, 98, *99*
 oat sprays and, 20, *21*
cranberries, 74, *75*
 mountain, *110*, 111, *112*, 118
currants, *90*, 91, 107
 Hermitage collection, *26*, 27, 29, 103

D

daisies, 72
 vases of, *10*, 11, 72, *73*
dandelions, 71
 Birbaum on, 33–34, 71, 118
 seed puffs, 27, 29, *33*, *67*, 118, *119*
daphne, 118, 120, *121*
Dehn, Lili, 54
Derbyshev, 108
diamonds, 72
 rose-cut, 19, 29, 36, *37*, 71
Disraeli, Benjamin, 82
Dudley, Countess of, 60

E

Easter
 eggs and, 17, 51
 flowers and, 48, 51
Edward VII, King, 81–82, 86, 92, 100
 mistress of, 90
eggs
 basket of flowers, 41, *43*, 44, *45*, 94
 Clock, 44, *45*, *47*
 Easter and, 17, 51
 Imperial, 41, 63, 94, 105
 lilies of the valley, 44, *45*, *46*
 rosebud, 51, 54, *55*
Eilers, Herman F., 107, 108
Elizabeth, Empress, 34, 47
Elizabeth of Hesse and by Rhine,
 Princess, 48
Elizabeth, Queen, 20
 collection, 94, 96–98, *99*
Elizabeth, Queen, II, 43
enameling, 71–72, 86, 118
England, Queen of, 11
 collections, 20
exhibitions, 41, 42, 44

F

Fabergé, Agathon K., 103
Fabergé, Alexander A., 103, 108
Fabergé, Carl
 influences on, 19, 118
 interview, 105
 London branch, 92, 100–101, 103, 105
 role in manufacturing, 66, 70
 workshops, 63, 100–101
Fabergé, Eugene I., 101

Fabergé, Nicholas, 101
Fabergé, Oleg Agafonovich, 105
Fabergé, Tatiana, 13
"Fauxbergé," 41
Feodorovna, Dowager Empress Marie, 72,
 74
 collection, 19, 20, 41, 42, 100, 105, 108,
 111, 113
 namesday, 51
 as Queen Alexandra's sister, 83, 86, 92
Feodorovna, Empress Alexandra
 children of Nicholas and, 48, 51
 collection, 41, 42, 44, 105, 108, 111
 love of flowers, 51, 54
 Nicholas' gifts to, 41, *43*, 44–48, *45–47*,
 49, 51–52, *52–53*, 54, *55*, 94
 photographs of, *34*, *43*, 51
 watercolor by, 17–19, *18*
Feodorovna, Grand Duchess Elizaveta, 44
Fersman Mineralogical Institute, 44, 106
fir trees, 105
flower(s). *See also specific flowers*
 drawing/painting, 48
 Easter and, 48, 51
 invoices for, 108, *109*
 manufacture of, 19, 66, 70–72
 Russian love of, 17, 19–20, 44, 47–48, 51,
 54, 66
 studies, 27, 34, *62*, 62–64, *64*, 66, *69*, 70
 wild, 72, 78, *79*, 98, *99*, 107–8
Forbes Collection, 44
forget-me-nots, *68–69*, 71, 74, *75*
 in Russia, *104*, 104–5
Fourrier, Aristide, 92
Froedman-Clousel, Boris, 106–7, *107*

fruits, 86, 89. *See also specific fruits*
fuchsias, 106, *107*

G

garnets, 72
Gautier, Theophile, 17, 48
gem setting, 86
George V, King, 82, 89, 94
George VI, King, 20
gold, 29, 101
 alloys, 71
 wire, 71
Gorshkova, Marie, 106
Guitaut, Caroline de, 13, 20

H

Hagen, Dudley, 103
Hanbury-Williams, Sir John, 54
hardstones, 63–64, 66, 70–72
 carving, 86, 89
 vases, 58, *59*
Harvard University's Glass Flower
 collection, 118
hawthorn, *2*, *3*, 56
Hermitage Museum, 39, 103
 currants, *26*, *27*, 29, 103
 narcissus, *32*, 39, 103
holly, 86, 90
Hvidöre villa, 94

I

Imperial family, flowers purchased by, 44,
 108, 111, 113–15
Imperial Glass Factory of Russia, 71
India Early Minshall Collection, 83

invoices, 108, *109*
Irène, Princess, 17, 19

J

jadeite bench, 106
jade vase, 78, *79*
Japanese floral composition, 34, *35*
Japanese garden, *102*, 103
Japanese influences, 19, 34
japonica (flowering quince), 27
 Queen Alexandra's, *80*, 80–81, 90, 101
jasper vases, 106

K

Karsavina, Tamara, 106
Keats, John, 27
Keppel, Mrs. George, 90
Knutsford, Viscount, 82, 83, 92
Koenig, 106
Kremlev, Peter, 70, 108
Kschessinska, Mathilda, 20, 105, 106

L

leaves, nephrite, 19, 29, 36, 71
ledgers, 11, 89, 100–101
lilac, *64*, 66, 71, 92
lilies of the valley, 19, 27, 74, *75*
 basket of, 44
 cherries and primula, 56, *57*
 egg, 44, *45, 46*
 in hardstone vase, 58, *59*
 Imperial basket of, 22, 48, *49*
 miniature basket of, 4, *5*, 22, *23*
 pearls for, 71
 Queen Alexandra's, *80*, 80–81, 94

Russian, 107, *107*, 110, 111
 with three sprigs in blossom, *16*, 17
 Vorontsov-Dashkov's, 105
lily leaf tray, *12*, 13
lingonberries, 86, *90*, 91
Livadia villa, *54*
Lobanov-Rostovsky, Princess Nina, 13

M

margarita flower, 56
Marie, Grand Duchess, 48, 51
 perfume, 56
 portrait of, 51, 52, *53*, 105
Marina of Kent, Princess, 22, 24
Marlborough House, 81
Mary, Queen, 89
 collection, 20, 43, 92, 94, 96, *97*
metals. *See also specific metals*
 alloys, 29, 66, 71
 precious, 71
Mikhailovich, Grand Duke Alexander, 106
Mikhailovich, Grand Duke Mikhail, 69
mineral stones, 29, 85
mistletoe spray, 14, *15*
mock orange, *64–65*, 66, 70
Mordvinoff, Countess Alexander, 19–20

N

namesdays, 48, 51
narcissus, 27, 29
 Hermitage collection, *32*, 39, 103
 sweet peas and, *32*, 39, 103
nephrite
 leaves, 19, 29, 36, 71
 vases, 34, *35*, 106

watering can, 4, *5*
Nicholas II, 19, 42, *43*, 83
 children of Alexandra and, 48, 51
 collection, 105, 108
 gifts from, 41, *43*, 44–48, *45–47, 49*,
 51–52, *52–53*, 54, *55*, 94, 105
Nicholas of Greece, Prince, 83
Nikolaevna, Grand Duchess Olga
 perfume, 56
 portrait of, 51, 52, *53*, 105
 watercolor by, 48, *50*, 51
Nobel, Alfred, 106

O

oat sprays, cornflowers and, 20, *21*
Oldenburg, Dukes of, 19
orange
 blossoms, 27, 51
 mock, *64–65*, 66, 70
orchids, 86

P

Paleologue, Maurice, 34, 36
pansies, 51–52, *52–53*, 72
 Queen Alexandra's, 83, *85*, 86, 105
 sprig, 24, *25*
 watercolor, *64*, 66
Paris Exposition, 41, 92
Pasternak, Boris, 29
Pavlovna, Anna, 106–7, *107*
Pavlovna, Grand Duchess Marie, *39*
 collection, 20, 22, 24, *32*, 39, 41, 103, 106,
 111, 113–15
pear blossom, 60, *61*
pearl(s), 19

flowers, basket of, 44
 for lilies of the valley, 71
Perchin, Michael, 29
perfumes, 19, 56
Peter the Great, 47
Petrov, Nikolai Alexandrovich and
 Dimitri, 72
pinecones, 29
pine trees
 in bowenite vase, 29, 30, *30–31*
 dwarf, 34, *35*, 82
 Queen Alexandra's, 82, *82*, 89, 101
Poincaré, Raymond, 34
Poklewski-Koziell, Stanislas, 90, 101
Ponsonby, Sir Frederick, 92
primula, lily of the valley and cherries, 56,
 57
purpurine, 70–71, *88*, 89

Q
quartz, 29, 70–71
The Queen's Own Warwickshire and
 Worcestershire Yeomanry Charitable
 Trust, 60
quince, flowering. *See* japonica

R
raspberries, 70, 89, 92, *93*
 rhodonite, 105
 in Russia, 107–8
rhodonite, 29
 bleeding heart, 70
 raspberries, 105
Ripon, Marchioness of, 94

rock crystal
 trompe l'oeil water of, 29, 34, *35*, 70, 76,
 77, 87, 88, 118, *122–23*
 vases, 8, *9, 10*, 11, 14, *15, 16*, 17, 19, 20, *21*,
 24, *25, 26*, 27, *32–33, 38*, 44, *45*, 56, *57*,
 60, *61, 67, 73, 75*, 80, *84–85*, 90, *93*, 97,
 99, 105, *110, 116, 119, 121*
Roosevelt, President, 54
rose(s), 72
 brooch, *6, 7*
 -cut diamonds, 19, 29, 36, *37*, 71
 Queen Alexandra's, 83, *84*, 85, 86, 94, *95*
 in rock crystal vase, 44, *45*
 wild, 8, *9*, 27, *37, 64, 66*, 74, *75*
rosebud egg, 51, 54, *55*
rowan tree, 86, *88*, 89, *90, 91*, 94
Rudanovsky, A. K., *32*, 39
 collection, 41, 103
Russia
 Fabergé flowers in, 103–15
 love of flowers in, 17, 19–20, 44, 47–48,
 51, 54, 66
 Tsarina of, 11
Russian Imperial collections
 Bulla on, 41
 search for, 11
Russian Revolution, 100–101, 103
Russian State Historical Archives
 (RGIA), 113

S
Sackville, Lady, 94, 103, 111
Sandringham House, 81–82, 86, 89, 92
scarlet plume flowers, *110*, 111
Schaffer, Mark, 13

silver, 29, 101
 alloyed with gold, 71
Skurlov, Valentin, 13, 17, 39
stones. *See* hardstones; mineral stones;
 specific stones
St. Petersburg, 11, 103, 107
 court style in, 34, 36, 47–48
strawberries, 92, *93*
 with achenes, 118, *122–23*
 in Russia, 107–8
sweet peas, narcissus and, *32*, 39, 103
Swezey, Marilyn, 11, 17

T
Tatiana, Grand Duchess, 48, 51
 perfume, 56
 portrait of, 51, 52, *53*, 105
Tillander-Godenhielm, Ulla, 11, 19
trays
 chestnut leaf, 13, *13*
 lily leaf, *12*, 13
trees. *See* fir trees; pine trees; rowan tree
turquoise, *68*, 69, 71

V
vases
 bowenite, 29, 30, *30–31*, *82*
 of daisies, *10*, 11, 72, *73*
 hardstone, 58, *59*
 jade, 78, *79*
 materials for, 106
 nephrite, 34, *35*, 106

rock crystal, 8, *9*, *10*, 11, 14, *15*, *16*, 17, 19,
 20, *21*, 24, *25*, *26*, 27, *32–33*, *38*, 44, *45*,
 56, *57*, 60, *61*, 67, 70, *73*, *75*, *77*, *80*,
 84–85, *90*, *93*, *97*, *99*, 105, *110*, *116*, *119*,
 121
Victoria, Princess, 94
Victoria, Queen, 54, 56
 collection, 81, 89
violets, 72, 76, *77*
 A La Vieille Russie's, *116*, 117, 118
Vladimir, Grand Duchess. *See* Pavlovna,
 Grand Duchess Marie
Vladimir, Grand Duke, 20
Vladimir Palace, 39
von Solodkoff, Alexander, 11–12
Vorontsov-Dashkov, I. I., 105

W
Ward, Cyril, 83
watercolors, 17, 19, 48
 by Feodorovna, Empress Alexandra,
 17–19, *18*
 flower studies, *62*, 62–64, *64*, 66, *69*
 forget-me-knots, *69*
 by Grand Duchess Olga, 48, *50*, 51
 pansies, *64*, 66
watering can, nephrite, 4, *5*
weddings, 48, 51
Wernher, Lady Zia, 69
Wigström, Henrik, 63, 66, 70–72
wood anemones, 70
World War II, 20
Worshipful Company of Goldsmiths of
 England, 101

Y
Yalta Peace Conference, 54
Yeliseev, 106
Youssoupof, Prince, 20

Photograph Credits